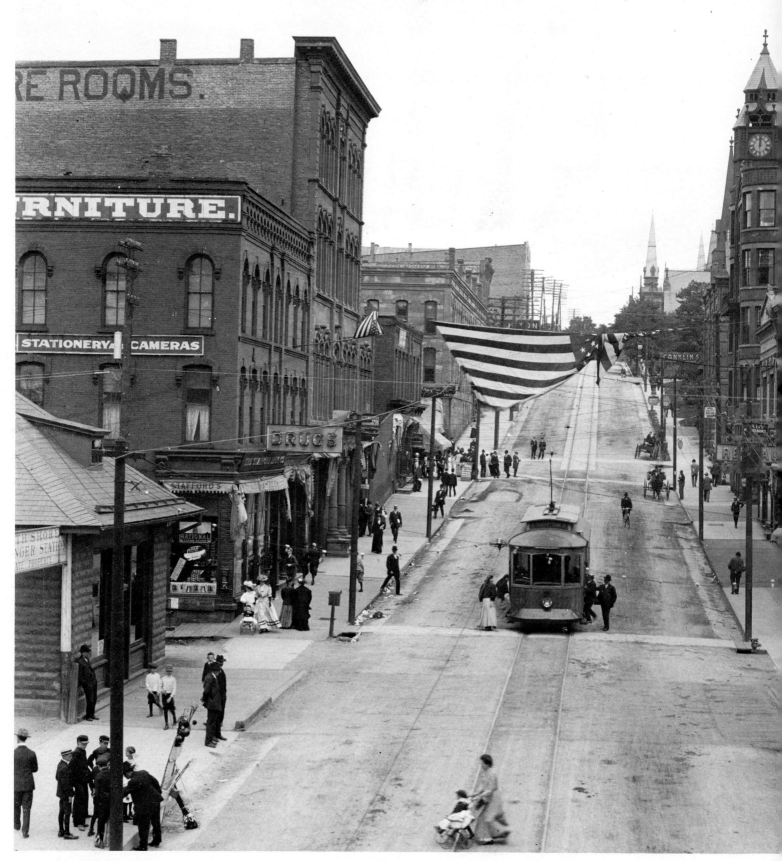

Marquette, Michigan, circa 1905

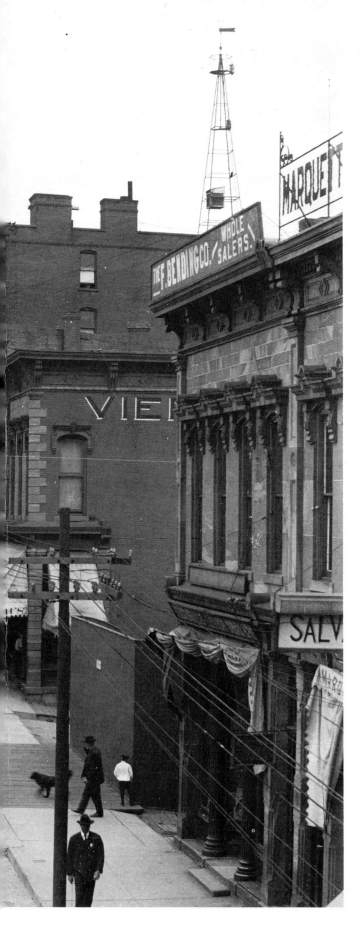

Main Street, U.S.A.
·In Early Photographs·

113 Detroit Publishing Co. Views

Edited, with an Introduction, by

CYNTHIA READ-MILLER

Curator of Graphics,
Henry Ford Museum & Greenfield Village,
Dearborn, Michigan

Captions by
BRIAN DOHERTY

HENRY
FORD
MUSEUM
&
GREENFIELD
VILLAGE

Published for Henry Ford Museum & Greenfield Village,
Dearborn, Michigan by

DOVER PUBLICATIONS, INC., New York

Copyright © 1988 by Dover Publications, Inc.
All rights reserved under Pan American and
International Copyright Conventions.

Published in Canada by General Publishing Company, Ltd.,
30 Lesmill Road, Don Mills, Toronto, Ontario.
Published in the United Kingdom by Constable and Company, Ltd.,
10 Orange Street, London WC2H 7EG.

Main Street, U.S.A., in Early Photographs: 113 Detroit Publishing Co. Views
is a new work, first published by Dover Publications, Inc., in 1988, in association
with Henry Ford Museum & Greenfield Village, Dearborn, Michigan.

Manufactured in the United States of America
Dover Publications, Inc.
31 East 2nd Street
Mineola, N.Y. 11501

Library of Congress Cataloging-in-Publication Data

Main Street, U.S.A., in early photographs.

Bibliography: p.
Includes index.
1. United States—Description and travel—1865–1900—Views. 2. United
States—Description and travel—1900–1920—Views. 3. Cities and towns—
United States—Pictorial works. 4. City and town life—United States—
History—Pictorial works. I. Read-Miller, Cynthia. II. Doherty, Brian. III.
Detroit Publishing Co.
E168.M26 1989 973 88-23748
ISBN 0-486-25841-6 (pbk.)

Introduction

The photographs in this book provide a representative sampling of the Detroit Publishing Co.'s views of American city streets from about 1890 up to the time of America's entry into World War One. The company photographed and printed a variety of images for popular consumption, producing a vast number of prints, photographs, and postcards, which it then marketed nationwide. Selected from a group of 25,000 of the company's original photographs in the collections of Henry Ford Museum & Greenfield Village, these 113 images present different regions, cities of various sizes, and diverse activities in a cross section of downtown commercial districts throughout the United States. These scenes serve not only as evocations of turn-of-the-century town and city life, but also as illustrations of an important facet of the work of one photographic publishing company.

MAIN STREET, U.S.A.

Although the term "Main Street" can be literally defined as the principal street in a town or city, in this book it tends to signify a dense commercial district. Historically, this type of district began as a village green or square, developed into a commercial row, and evolved into a distinct commercial area or grouping of business and civic buildings in larger cities. Something of this evolutionary sequence can be traced as one moves from photographs of small towns to those of larger towns and cities of increasing size. Few of the streets included here can be identified as a town's principal street, and fewer still are named Main Street. What ties these images together is their depiction of commercial buildings clustered together in conjunction with transportation systems and populated areas.

Turn-of-the-century America was in transition from a rural to an urban society. In 1890, a little more than one-third of the nation's sixty-three million people lived in towns and cities. By 1920, over half of the nation's 106 million people were residing in urban areas. Immigration from overseas and from the American countryside swelled the population of urban centers with people brought face to face, often for the first time, with the demands and opportunities of city life. Simultaneously, those opportunities were enlarged by new technologies, consumer goods, and retailing practices. Confronted with the anonymity of urban life, people sought new means of identifying themselves and their peers within the city. Individuals and families carved niches and developed identities for themselves by their choices in housing, domestic furnishings, and clothing, as well as by participation in churches, ethnic clubs, fraternal organizations, and neighborhood associations.

In this era, cities developed increasingly complex political bureaucracies, transportation systems, public utilities, and architectural traditions. Combined with a city's economic history, cultural heritage, and geographic location, these factors contributed to the distinctive character of each community. Glimpses of the various individual municipal styles that resulted are contained in the photographs in this book. But also evident in these views are the commonalities that defined the urban landscape: the profusion of transportation systems and communication lines, the variety of construction materials and architectural styles, the density of activities and businesses carried on within limited space, and the diversity of people on streets and sidewalks.

These are not the often grim urban scenes documented in the same era by Jacob Riis and other socially concerned photographers. Those images do not appear in this volume because the Detroit Publishing Co. was interested less in social commentary than in appealing to a broad middle-class audience. These are the streets that attracted Americans, old stock and new, to the city in unprecedented numbers. These are the scenes that inspired Sinclair Lewis's

Main Street (1920) and the Lynds' *Middletown* (1929). This is Main Street America at the turn of the century, to be perused, studied, and enjoyed from many perspectives.

THE DETROIT PUBLISHING CO.

In addition to the valuable historical content of these images, a pertinent aspect they share is that they were all produced by one company. The Detroit Publishing Co. became a comprehensive publisher of photographic images around the turn of the century. Started in 1897 in Detroit, Michigan, it was known until 1905 by its two subsidiary operations, the Photochrom Co., dealing with the production of color prints, and the Detroit Photographic Co., responsible for the publishing and distribution of photographic views made by the company. A timely joining of entrepreneurial energies helped assure the early success of the company.

William A. Livingstone (an engineer and son of wealthy Detroit shipping magnate, newspaper publisher, and financier, William Livingstone), joined forces with a local photographer, Edwin H. Husher, to form the company. Livingstone obtained from the Photoglob Company of Zurich, Switzerland, the North American rights to an astounding new photolithographic process called Photochrom, to produce, in quantity, color prints that retained their photographic verisimilitude while capturing the vibrant colors of the popular chromolithographs of the late nineteenth century. He even persuaded an expert in the process, Albert V. Schuler, and a small crew of draftsmen from Switzerland to work for the new company. Since color photography as we know it did not then exist, holding exclusive rights to this Swiss method gave the company a significant advantage over its competitors. Besides producing these distinctive Photochrom color prints, the company also published color postcards, sepia-toned photographic prints, and lantern slides, all based on a huge inventory of photographic negatives.

The keystone of the company's success, pioneer American photographer William H. Jackson, joined the venture in 1898, bringing 10,000 of his superb glass-plate negatives to form the core of the visual publication material. In his early years with the company, Jackson traveled throughout the United States, Canada, and the Caribbean, taking his own photographs and purchasing the photographic stock of local photographers. In 1902, Jackson and a crew of cameramen traveled throughout the country in a specially equipped railroad car containing a photographic studio and gallery. At its peak, the company drew upon 40,000 negatives for its publishing effort. Jackson and the other company photographers captured images ranging from the exotic to the ordinary, including special events, daily activities, resorts, cruise ships, and views of cities and countrysides throughout the United States and the world. The company also made photographs of businesses to be used in advertisements and promotions, and photographically reproduced art works from the collections of various museums.

By 1903, Edwin Husher, who had overseen the production of the color prints, resigned from the Photochrom Co. and Jackson began devoting most of his energies to supervising the publishing work in Detroit, but always keeping a hand in the making and acquiring of new photographic negatives. He supervised a crew of forty artisans and a dozen traveling salesmen at a time when the company sold seven million prints annually. By this time the company had developed an impressive distribution system combining worldwide retail sales, sales at resorts and tourist attractions, and mail-order sales. They maintained retail outlets in Detroit, New York City, Boston, and Los Angeles. They had retail exchange agreements with the Swiss company Photoglob and with the English licensees of the Photochrom process, the Photochrom Co., Ltd., in London. Public libraries and schools led the mail-order sales, but sales to individuals and independent retail outlets were not ignored by the company. The company's encyclopedic coverage of photographic images and wide variety of sales approaches demonstrated its eagerness to produce and distribute material to the broadest possible audience.

The Detroit Publishing Co.'s sales boom in the early years of this century slowed considerably when its line of business was categorized by the federal government during World War I as "non-essential," i.e., not vital to the war effort. It was, therefore, difficult to acquire material or keep workers employed for the duration of the war. Never really recovering from this slowdown, and feeling the bite of

competitors using newer and less labor-intensive visual-reproduction methods, in 1924 the company went into receivership and continued on a smaller scale. Robert B. Livingstone, brother of William A. Livingstone, attempted to carry on the company after William's death in 1924, although most of his efforts were directed toward selling the more than 2,000,000 postcards and prints still on hand. These efforts ended with his death in 1936.

Even during its most vigorous years, the Detroit Publishing Co. did not produce prints or postcards from all of its photographic stock. After Robert Livingstone's death, the company's extant photographic negatives, master photoprints, sepia and color prints, postcards, and negative record log began a journey that has preserved them for today's researchers.

Edison Institute (now known as Henry Ford Museum & Greenfield Village) acquired the remaining Detroit Publishing Co. materials in 1937 from the estate of Robert B. Livingstone. After a decade of persistence by William H. Jackson's son, Clarence, the institute agreed to donate the negatives of Western views to the Colorado Historical Society to join the growing collection of Jackson material there, and the negatives of Eastern United States and foreign views to the Library of Congress in Washington, D.C. The company's negative record log was also sent to Colorado. The Detroit Publishing Co. material in the collections of Henry Ford Museum & Greenfield Village today consists of 25,000 vintage photoprints, 15,000 postcards, and 5,000 color and sepia photomechanical prints. The original photographs are contact prints made by the company from the original glass-plate negatives. They often contain written information about the topic, instructions concerning reproduction methods, and, occasionally, retouching marks. In this way the photographs serve as a visual record documenting the company as well as an era in American life.

The Detroit Publishing Co. photographed and reproduced these informative and revealing scenes for popular distribution and monetary gain. Today we benefit from their unique perspective and are offered in this volume an accurate, detailed view of an exciting, changing urban environment that existed over seventy-five years ago.

Acknowledgments

Individual photograph captions have been prepared by Brian Doherty from information provided by the following sources (cities in question identified within parentheses wherever necessary): Albany Public Library; Albuquerque Public Library, Special Collections Branch; Ann Arbor Public Library; Atlantic City Free Public Library; Reese Library, Augusta College; Museum and Library of Maryland History, The Maryland Historical Society (Baltimore); Rockingham (Vt.) Free Public Library (Bellows Falls); Broome County (N.Y.) Historical Society (Binghamton); Birmingham Public Library; Boston Public Library; Buffalo Evening News Library; Fletcher Free Library (Burlington); Cambridge Public Library; Charleston Library Society; Chattanooga–Hamilton County Bicentennial Library; Chicago Historical Society; The Cincinnati Historical Society; Cleveland Public Library; Center of Science & Industry (Columbus); Denver Public Library; Detroit Public Library, Burton Historical Collection; City of Duluth, Department of Libraries; El Paso Public Library; Fall River Public Library; Rosenberg Library (Galveston); Suomi College, Finnish-American Historical Archives (Hancock); Tri-Lakes Regional Library (Ark.; Hot Springs); Historic Landmarks Foundation of Indiana (Indianapolis); Jacksonville Public Libraries; The Kansas City Museum; Kingston Area Library; Knox County Public Library System, McClung Historical Collection (Knoxville); Woodruff Memorial Library (La Junta); Lansing Public Library; Arkansas History Commission (Little Rock); Littleton Area Historical Society; Los Angeles Area Chamber of Commerce; Louisville Free Public Library; University of Lowell; Mackinac Island Public Library; Manchester Historic Assocation; City of Manchester, City Library; The Marquette County Historical Society, Inc.; Memphis–Shelby County Public Library & Information Center; Minneapolis Public Library and Information Center; Mobile Public Library; Alabama Department of Archives and History (Montgomery); Mount Vernon Public Library, Local History; Ms. Maggie McShan (Needles); The Historical Society of Newburgh Bay and the Highlands; City of New Orleans, Public Library; The New York Public Library; Norfolk Public Library System; North Adams Public Library; Oakland Public Library, Oakland History Room; Weber County (Utah) Library (Ogden); The Free Library of Philadelphia, Map Collection; The Historical Society of Western Pennsylvania (Pittsburgh); Plattsburgh Public Library; Plymouth Public Library; Maine Historical Society (Portland); Oregon Historical Society (Portland); Portsmouth Public Library; Adriance Memorial Library (Poughkeepsie); The Rhode Island Historical Society (Providence); Pueblo Library District, Community Services; A. K. Smiley Public Library (Redlands); The Valentine Museum (Richmond); Rochester Historical Society; Rutland Free Library; Historic St. Augustine Preservation Board; St. Louis Mercantile Library Association; Minnesota Historical Society (St. Paul); Salem Public Library; San Diego Historical Society; San Francisco Public Library, San Francisco Archives; Historical Society of Saratoga Springs; Bayliss Public Library (Sault Sainte Marie); Georgia Historical Society (Savannah); Historical Society of Seattle and King County; Connecticut Valley Historical Museum (Springfield); Onondaga Historical Association (Syracuse); Hillsborough County Historical Commission Museum Library (Tampa); Toledo–Lucas County Public Library; Oneida Historical Society (Utica); Warren County–Vicksburg Public Library; District of Columbia Public Library (Washington); Worcester Historical Museum. In addition, the following reference works were consulted: *Dictionary of American Biography,* Charles Scribner's Sons, New York, 1957; *Encyclopaedia Britannica* (various editions); and *The National Register of Historic Places,* U.S. Dept. of the Interior, National Park Service, Washington, D.C., 1976.

List of Illustrations

Albany (New York), 1
Albuquerque (New Mexico), 2
Ann Arbor (Michigan), 3
Atlantic City (New Jersey), 4, 5
Augusta (Georgia), 6
Baltimore (Maryland), 7
Bellows Falls (Vermont), 8
Binghamton (New York), 9
Birmingham (Alabama), 10
Boston (Massachusetts), 11–16
Buffalo (New York), 17
Burlington (Vermont), 18
Cambridge (Massachusetts), 19
Charleston (South Carolina), 20
Chattanooga (Tennessee), 21
Chicago (Illinois), 22–28
Cincinnati (Ohio), 29
Cleveland (Ohio), 30
Columbus (Ohio), 31
Denver (Colorado), 32
Detroit (Michigan), 33
Duluth (Minnesota), 34
El Paso (Texas), 35
Fall River (Massachusetts), 36
Galveston (Texas), 37
Hancock (Michigan), 38
Hot Springs (Arkansas), 39
Indianapolis (Indiana), 40
Jacksonville (Florida), 41

Kansas City (Missouri), 42
Kingston (New York), 43
Knoxville (Tennessee), 44
La Junta (Colorado), 45
Lansing (Michigan), 46
Little Rock (Arkansas), 47
Littleton (New Hampshire), 48
Los Angeles (California), 49
Louisville (Kentucky), 50
Lowell (Massachusetts), 51
Mackinac Island (Michigan), 52
Manchester (New Hampshire), 53
Marquette (Michigan), 54
Memphis (Tennessee), 55
Minneapolis (Minnesota), 56
Mobile (Alabama), 57
Montgomery (Alabama), 58
Mount Vernon (New York), 59
Needles (California), 60
Newburgh (New York), 61
New Orleans (Louisiana), 62, 63
New York (New York), 64–70
Norfolk (Virginia), 71
North Adams (Massachusetts), 72
Oakland (California), 73
Ogden (Utah), 74
Philadelphia (Pennsylvania), 75–78
Pittsburgh (Pennsylvania), 79
Plattsburgh (New York), 80

Plymouth (New Hampshire), 81
Portland (Maine), 82
Portland (Oregon), 83
Portsmouth (New Hampshire), 84
Poughkeepsie (New York), 85
Providence (Rhode Island), 86
Pueblo (Colorado), 87
Redlands (California), 88
Richmond (Virginia), 89
Rochester (New York), 90
Rutland (Vermont), 91
St. Augustine (Florida), 92
St. Louis (Missouri), 93
St. Paul (Minnesota), 94
Salem (Massachusetts), 95
San Diego (California), 96
San Francisco (California), 97
Saratoga Springs (New York), 98
Sault Sainte Marie (Michigan), 99
Savannah (Georgia), 100
Seattle (Washington), 101, 102
Springfield (Massachusetts), 103
Syracuse (New York), 104
Tampa (Florida), 105
Toledo (Ohio), 106
Utica (New York), 107
Vicksburg (Mississippi), 108
Washington (D.C.), 109–112
Worcester (Massachusetts), 113

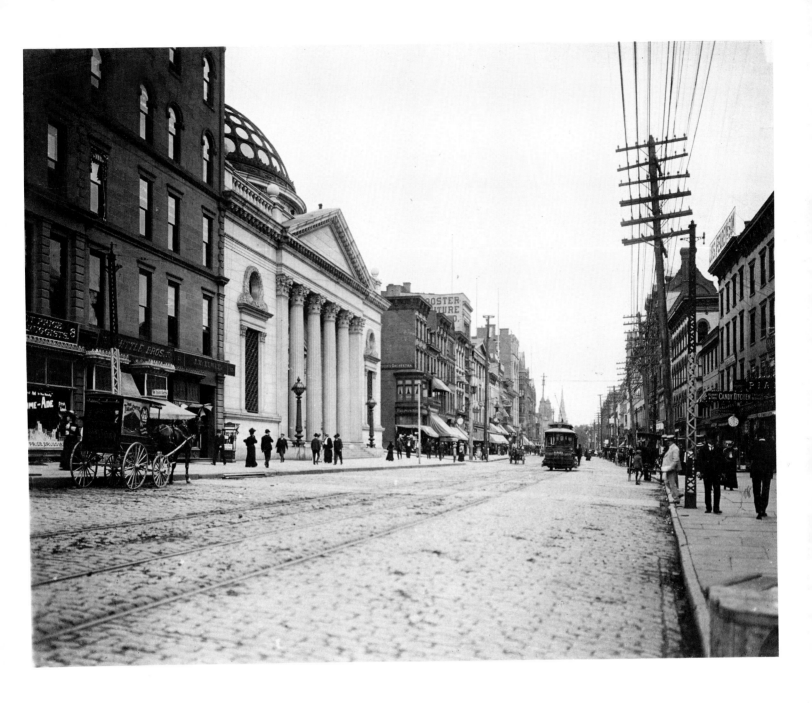

Albany, New York, circa 1910 This is North Pearl Street, looking north from the corner of State Street. The Tweddle Building (demolished in 1915) is on the extreme left; to its right is the classical façade of the Albany Savings Bank. The Bank, an Albany landmark since 1899, was torn down in 1976.

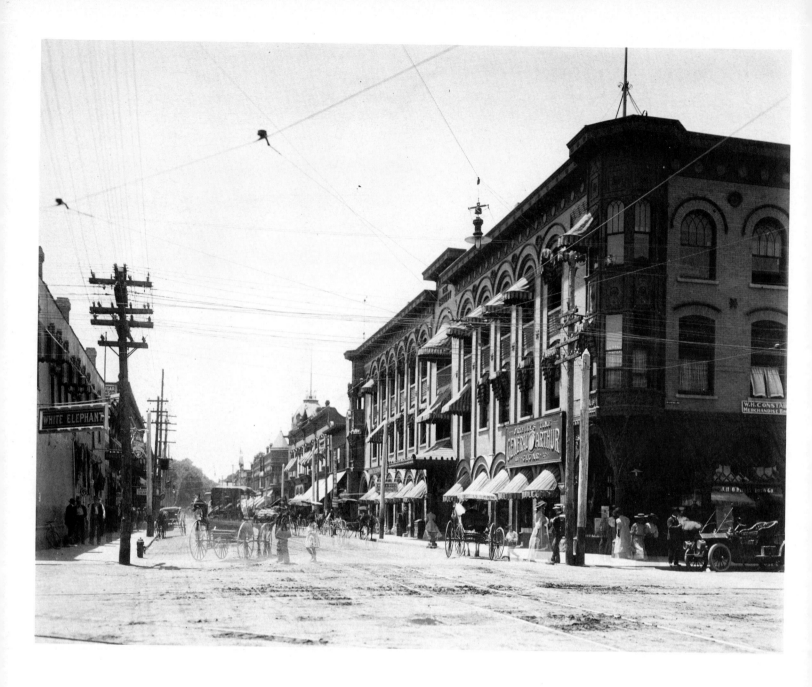

Albuquerque, New Mexico, circa 1908 This view is looking down Second Street from the crossing of Central Avenue (known as Railroad Avenue until the 1910's). The Barnett block, on the right, was built in 1902 by New Yorker Joseph Barnett. Barnett was a businessman who operated a number of notable Albuquerque firms including the Palace Billiard Parlor, the Crystal and Lyric theatres and the St. Elmo and White Elephant saloons. The White Elephant gave way to the still extant Sunshine Building (another Barnett project). The Barnett block burned down in 1963 and was replaced by a parking lot.

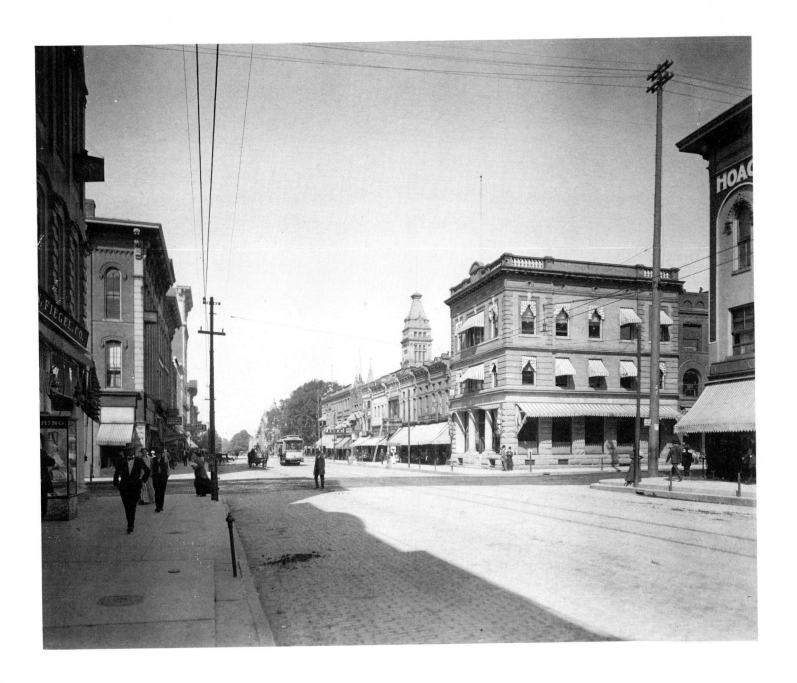

Ann Arbor, Michigan, 1906 or 1907 This photo shows the intersection of Main and Washington Streets, looking north up Main Street. The steeple in the center belongs to the County Courthouse. On the right is Hoag's Five and Ten-Cent Department Store. Across Washington Street is the State Savings Bank. On the left is Reule, Conlin, Fiegel, clothiers, and to its right is the Ann Arbor Trades Council Hall.

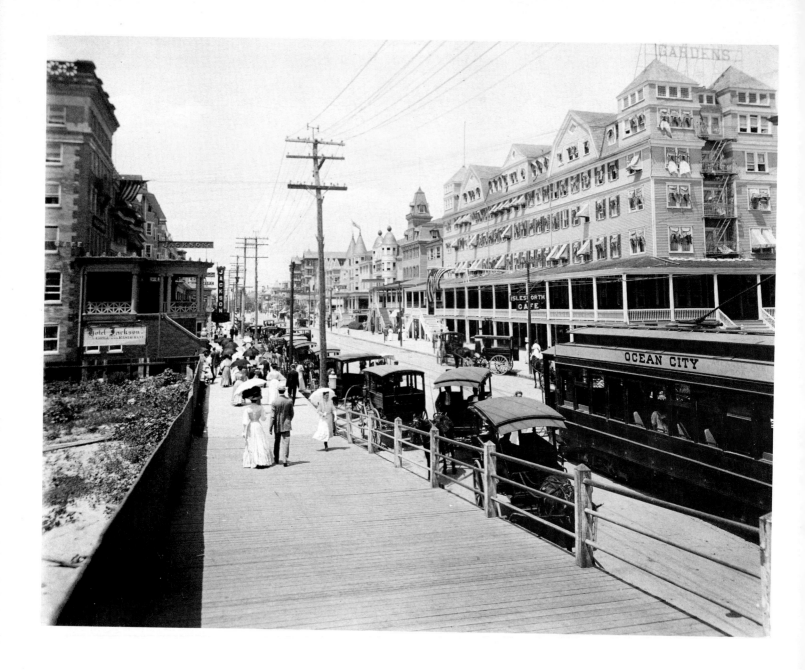

Atlantic City, New Jersey, circa 1905 This photograph shows the Boardwalk incline descending from the Boardwalk and looking west down Virginia Avenue, away from the beach. On the left is the Hotel Jackson, on the right is the Hotel Islesworth.

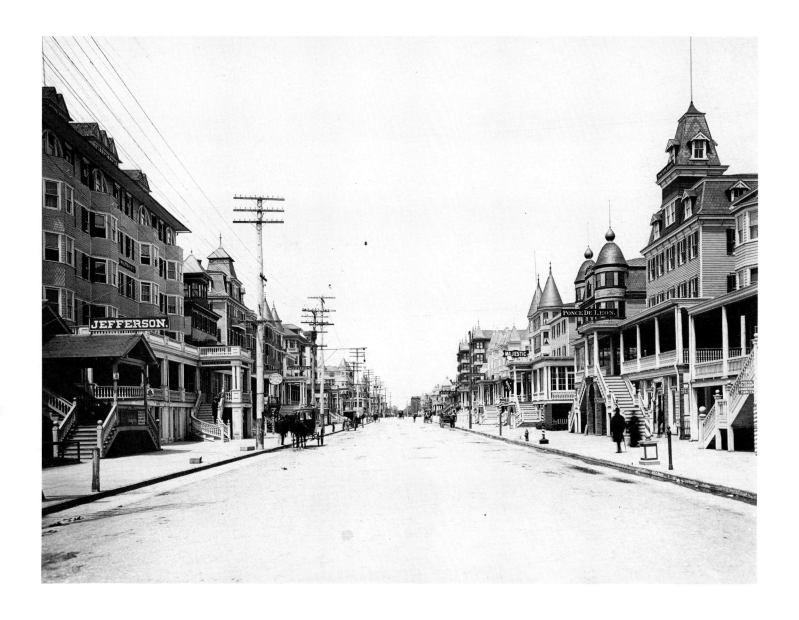

Atlantic City, New Jersey, circa 1905 A bit further west on Virginia Avenue from the previous picture one can see the Jefferson Pool and Billiard Parlor (just west of the aforementioned Hotel Jackson) on the left, and to the right the mansarded Hotel Ponce de Leon (adjacent to the Islesworth). Left of the Ponce de Leon is the Hotel Majestic.

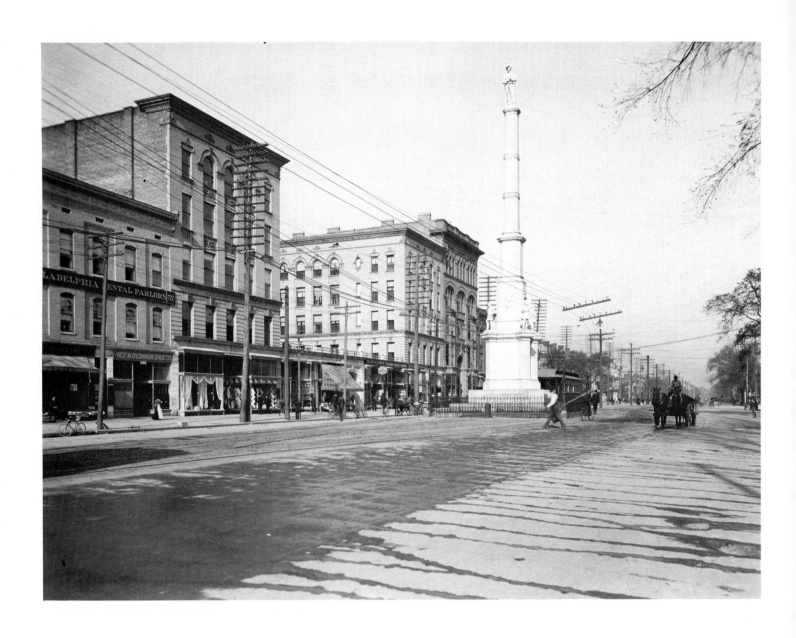

Augusta, Georgia, circa 1895 Rising high above the middle of Broad Street (the north side, seen to the left in the photo) is the Confederate Monument, erected in 1878. The rifleman chosen as the model for the statue atop the monument was Berry Benson, a colorful soldier and writer (1843–1923). A witness to much of the Civil War, from Fort Sumter to Appomattox, Berry Benson set down his recollections, supplemented by those of his brother Blackwood, in his "War Book." The monument still stands to this day.

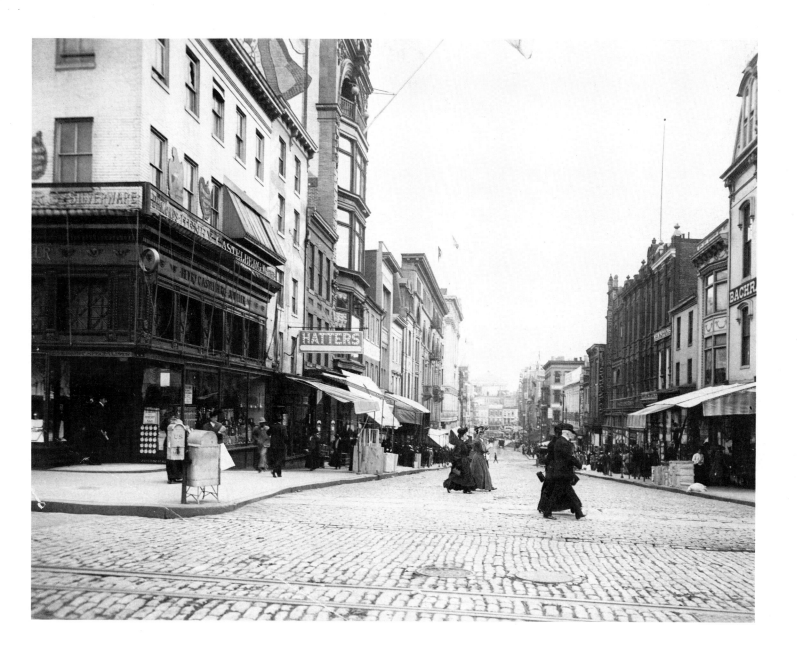

Baltimore, Maryland, circa 1907 This is a view looking east down Lexington Street from the intersection of Eutaw Street. The cross streets one encounters as one proceeds east on Lexington Street are: Howard Street, Park Avenue and Liberty Street. The greater proportion of the firms visible here were doing business between 1895 and 1930. For example, The Maryland Optical Company, seen along the south side of Lexington Street, began operations at this location in 1905.

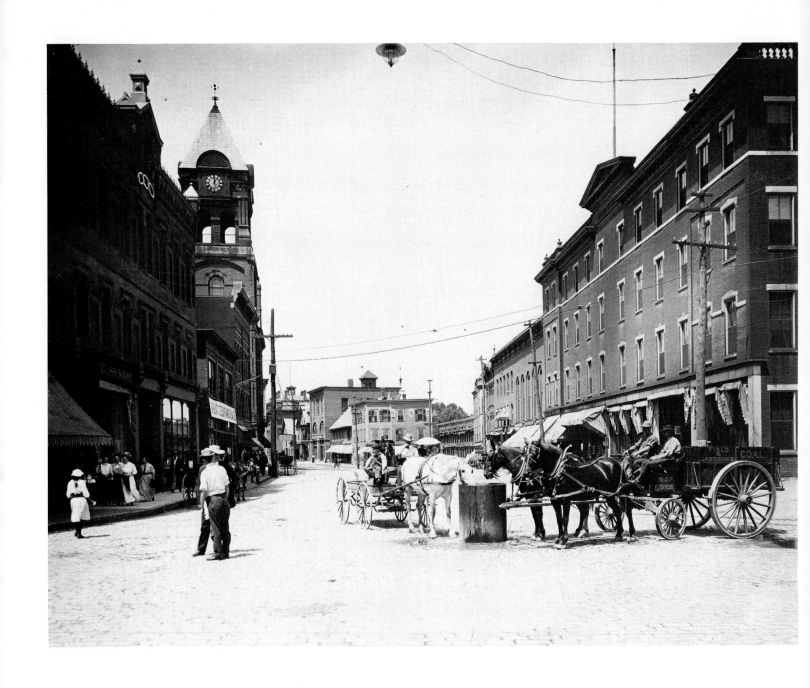

Bellows Falls, Vermont, 1907 This scene depicts the intersection of three streets: Bridge (off to the extreme right), Westminster (off to the extreme left) and the broad street we are looking north on, Rockingham Street. The large building on the right is the old Hotel Windham, which was plagued by a series of fires after 1912, and now stands vacant. To the left, with its distinctive clock tower, is the old Town Hall, which burned down in 1925 but was rebuilt and is still standing. The building with the 25's was Baldasaro's fruit store and is now a restaurant. Two doors north, with a cupola-like structure atop it, is the old fire station, now stores and apartments.

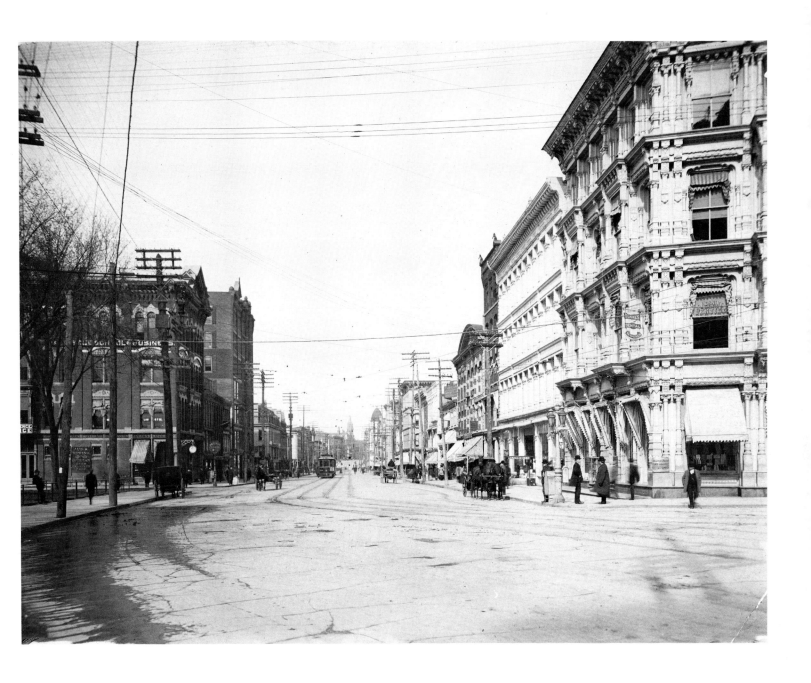

Binghamton, New York, circa 1905 Here, in the heart of Binghamton, 1905, we are looking down Court Street toward the west and the Chenango River. The cast-iron-faced building on the right (1876, still standing) is the Perry Block, which housed the offices of Isaac Perry, architect for the last eleven years of the construction of the New York State capitol, and which was home to McLeans Department Store for 98 years. The tree-filled corner at the extreme left is part of (Broome County) Court House Square. Just west of the Square is the McNamara business block (1870 to 1916). The distant tower at the photo's center is Binghamton High School (on the other side of the Chenango).

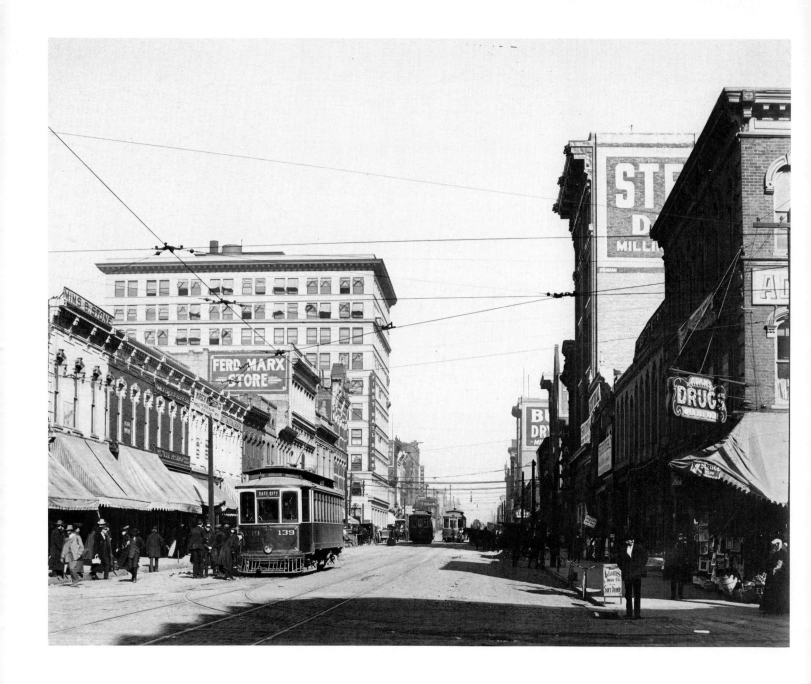

Birmingham, Alabama, circa 1909 The tallest structure in this photograph is the First National Bank building, built in 1904 (center). Second Avenue North recedes into the east from the camera position at the intersection with Nineteenth Street. Between 1900 and 1910 the population of Birmingham jumped from 38,415 to 132,685, a reflection of the tremendous economic growth experienced by this industrial center.

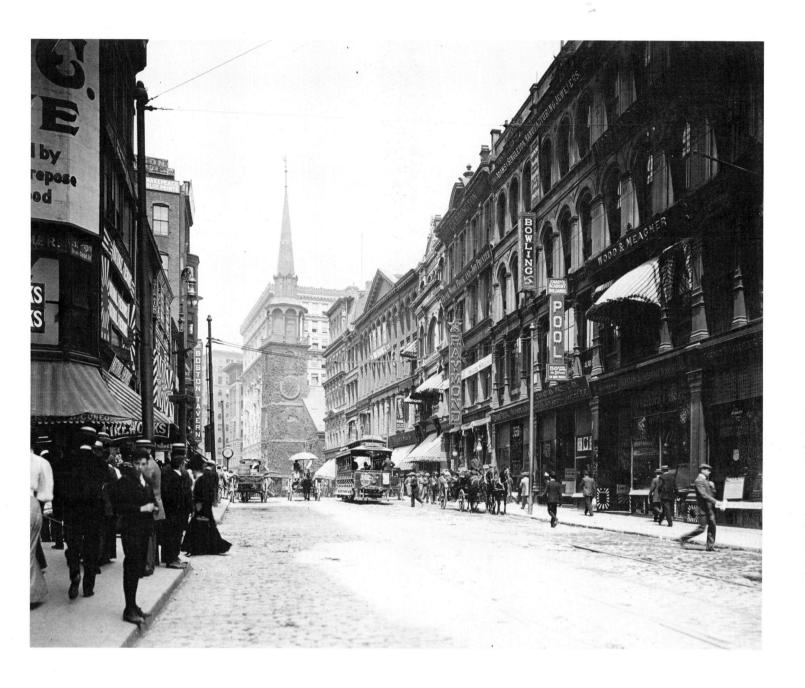

Boston, Massachusetts, 1906 This is Washington Street looking north. On the left, the men
in straw boaters are congregating at the corner of Bromfield Street. The church (left of center)
is the Old South Meeting House (1730, designed by Robert Twelves). Here many political
gatherings took place in the period just before the Revolutionary War, including the ones
leading to the Boston Tea Party, December 16, 1773 (there is a sample of the original Tea Party
tea on display). The Meeting House was built for a congregational society that began in 1669
and was known variously as the Third Church of Boston, South Church and Old South Church.
The structure survived the disastrous fire of 1872 that gutted downtown Boston east of
Washington Street. Rescued from demolition four years later, it has since been owned by the
Old South Assocation, which now operates it as a museum with assistance from the National
Park Service. Also notable in this picture are the Old South Building (behind the Meeting
House) and the Raymond department store (center).

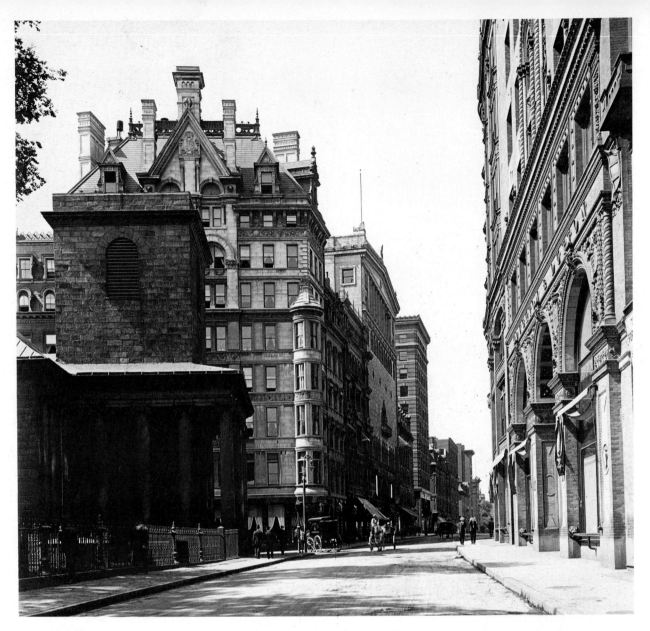

Boston, Massachusetts, circa 1905 *(two views)* ABOVE: Tremont Street, looking southwest from a vantage just north of School Street, presents us with a number of interesting structures. King's Chapel, at left, was the first Episcopal church in Boston (1686). Its original structure was replaced in 1754 (begun 1749) by this Peter Harrison (1716–1775) masterpiece. King's Chapel changed affiliation in 1785, becoming America's first Unitarian church. The original Parker House is to the left of the King's Chapel bell tower and, to its right, the addition of 1884, the fanciful landscape of its roof clearly visible here. Three doors south is Tremont Temple (1898, Clarence H. Blackall) with its notable façade, consisting of, among other things: a riotously colorful mosaic of 10,000 terra-cotta tiles; Venetian arcades; and arrangements of colored marble. The edifice is home to the Tremont Baptist Church (formed in 1838 on strong abolitionist principles). On the far right is the Albion Building, with a Houghton and Dutton department store at street level.

OPPOSITE: Washington Street, from the vantage of Milk Street up to State Street, was Boston's old "Newspaper Row." Around the time of this photo there were more than eight daily papers in Boston. On the west side of the street is the Herald Building, since demolished, with its sharply peaked tower. The Boston Globe Building bears the words "Boston Globe." Emblazoned with "Sunday Globe" is the Boston Advertiser Building. Both buildings are gone. The three large buildings on the right are still standing, including the Old South Building (1903).

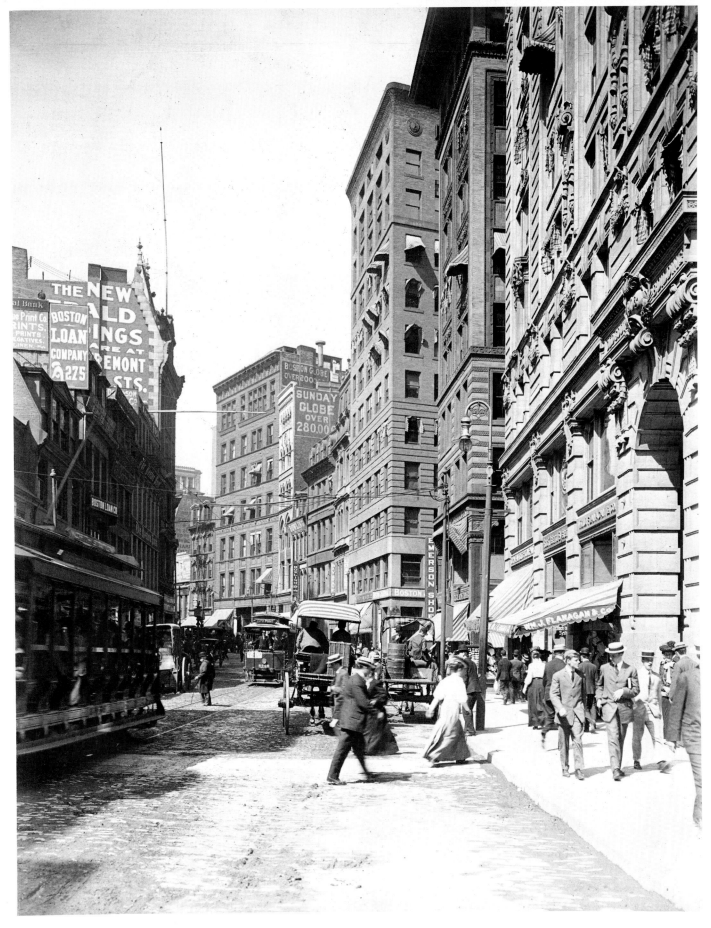

13

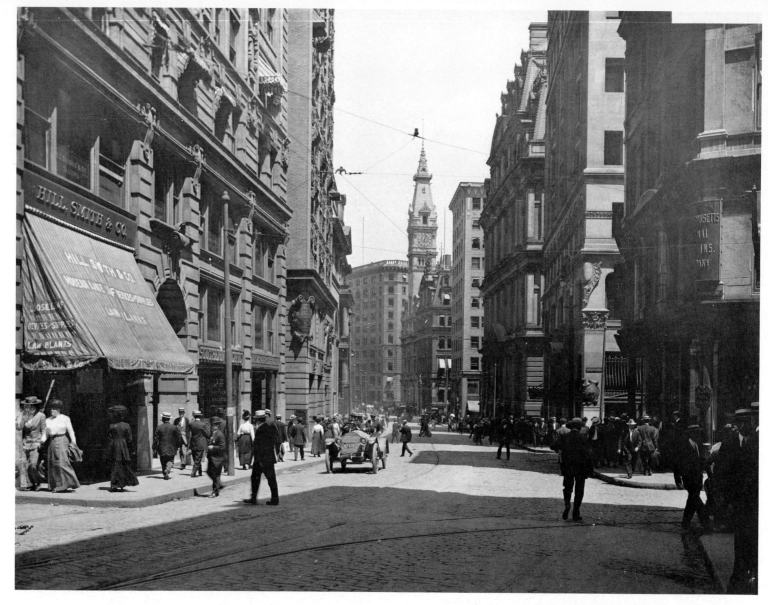

Boston, Massachusetts, 1911 (ABOVE) Looking east down Milk Street toward Post Office Square, this view centers on the elegant tower of Mutual Life of New York (Peabody and Stearns, architects). New England Mutual Life, designed by Nathaniel J. Bradlee, stands adjacent to it on the right with its mansard roof. These splendid high-Victorian structures were both completed in 1874 and demolished in 1945 to make way for a parking garage. Just visible across from these are the tiered columns of Alfred B. Mullett's Post Office and Sub-Treasury, built in 1869 and replaced in 1933 by the hulking Art Deco mass of the present Post Office.

Boston, Massachusetts, circa 1900 (OPPOSITE) This photo shows School Street looking west to the crossing of Tremont Street (in the middle of the picture where the traffic appears more congested), where School runs into Beacon Street. The first Parker House (1854) has a flagpole protruding from the second-floor balcony, and to its right is the fabulous addition of 1884 with its massive chimneys. The Parker House, the birthplace of broiled scrod and Parker House rolls, is one of Boston's most famous hotels (Charles Dickens stayed here in 1867) and is the oldest in continuous operation in the United States. These structures were replaced in 1927 by the current Parker House, a larger and more sedate edifice. Just behind the tree is King's Chapel, designed by Peter Harrison and completed in 1754. Above King's Chapel is the Albion Building (1888, Cummings and Sears), now demolished.

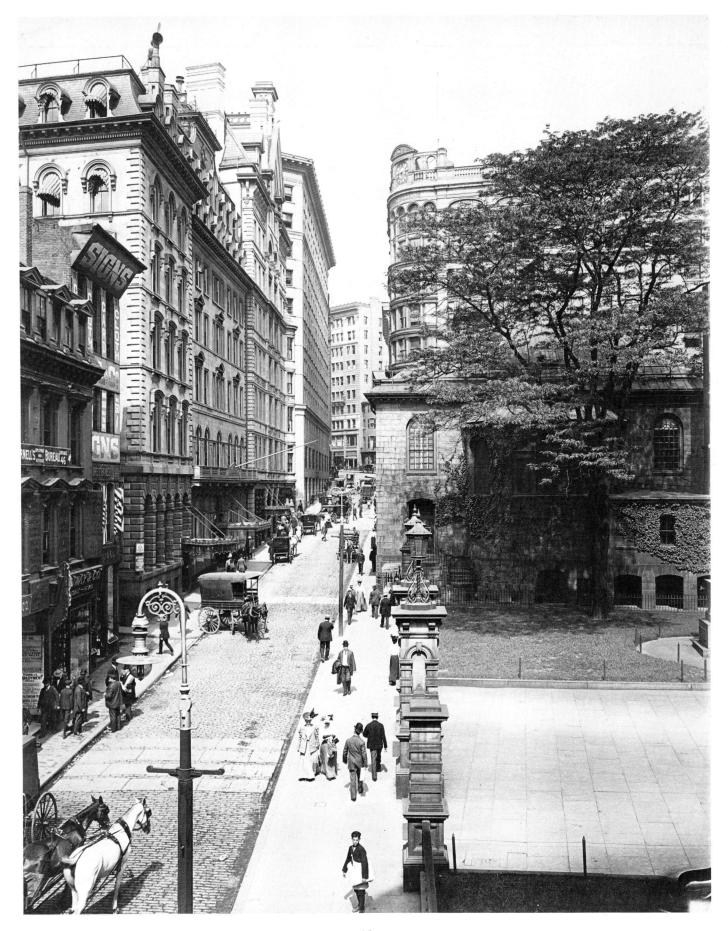

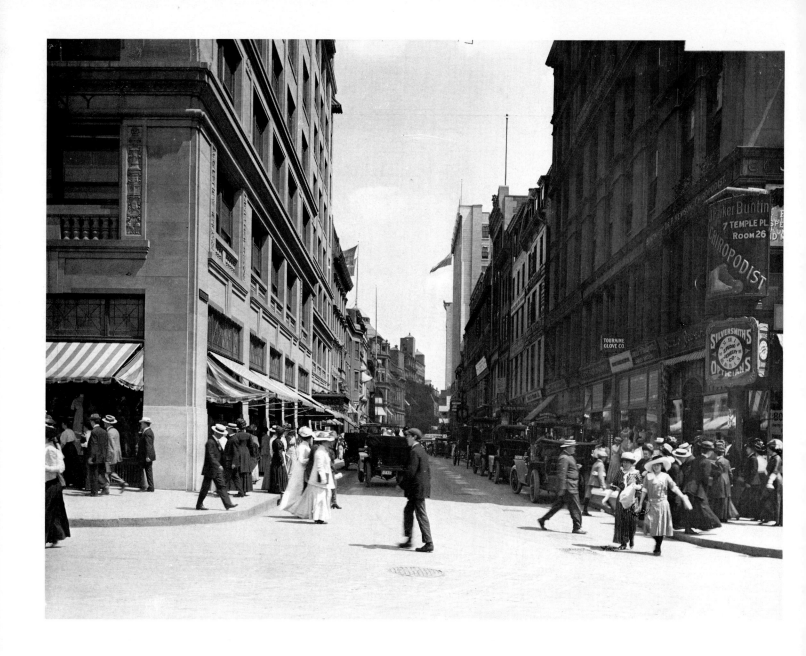

Boston, Massachusetts, circa 1915 Temple Place derives its name from the Masonic Temple that once stood where R. H. Stearns (at left) appears in this photo. R. H. Stearns, quite new in this picture, was a department store in operation until the 1960's. The building is still there. This view looks southeast down Temple Place from Tremont Street toward Washington Street, where Temple Place changes to Avon Street. At the corner of Avon and Washington (center) can be seen the clock face of another department store, Jordan Marsh Co. The commercial character of Tremont Street and the streets running off from it is well illustrated in this photograph.

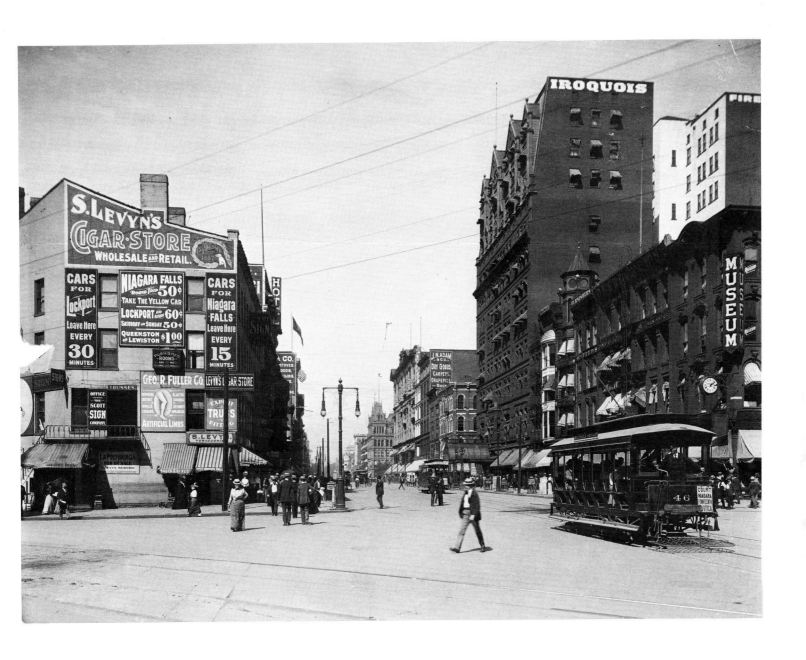

Buffalo, New York, circa 1905 The viewer is looking north up Main Street from Shelton Square. The Iroquois Hotel (with "Iroquois" on its side) had its top three floors superadded for the Pan-American Exposition in 1901. The Iroquois became the Gerrans Office Building in 1923 when its owner, Ellsworth Statler, opened another hotel in Buffalo. Indicated by its sign, J. N. Adam & Co., a department store owned by Mayor Adam, was in operation until 1959. The structure with tower toward the right was later transformed into the Strand Theatre, among the earliest movie theaters. Not one of the buildings in this picture still exists.

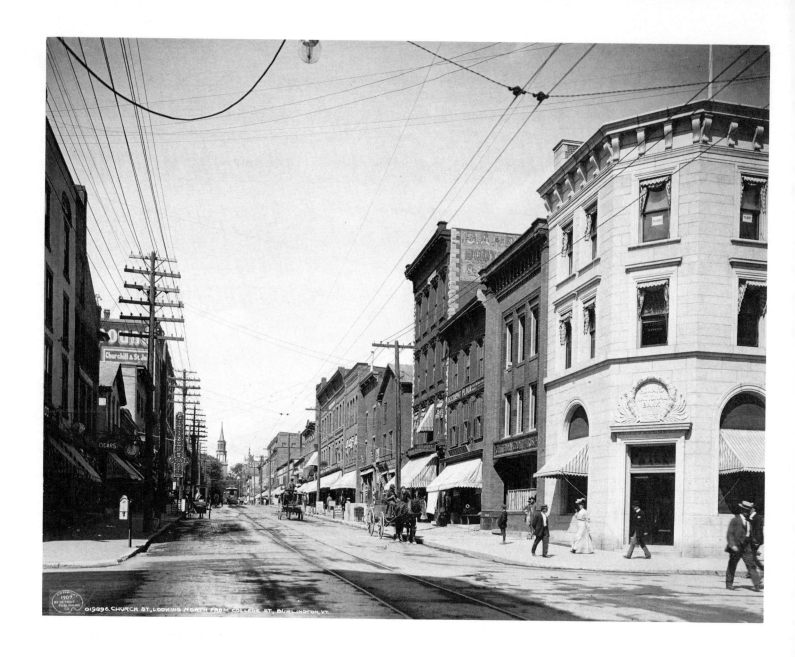

Burlington, Vermont, circa 1905 This is Church Street looking north from College Street toward the Unitarian Church (1816, Peter Banner, architect), a Federal-style landmark fronting Pearl Street at the northern terminus of Church Street. The granite building at far right housed the Howard National Bank (1903) and still stands, although its form has been significantly altered by expansion. Church Street has since been converted into a pedestrian mall from Pearl Street to Main Street (one block south of College Street), complete with sidewalk cafés and open-air markets, yet much of the architecture in this view has survived.

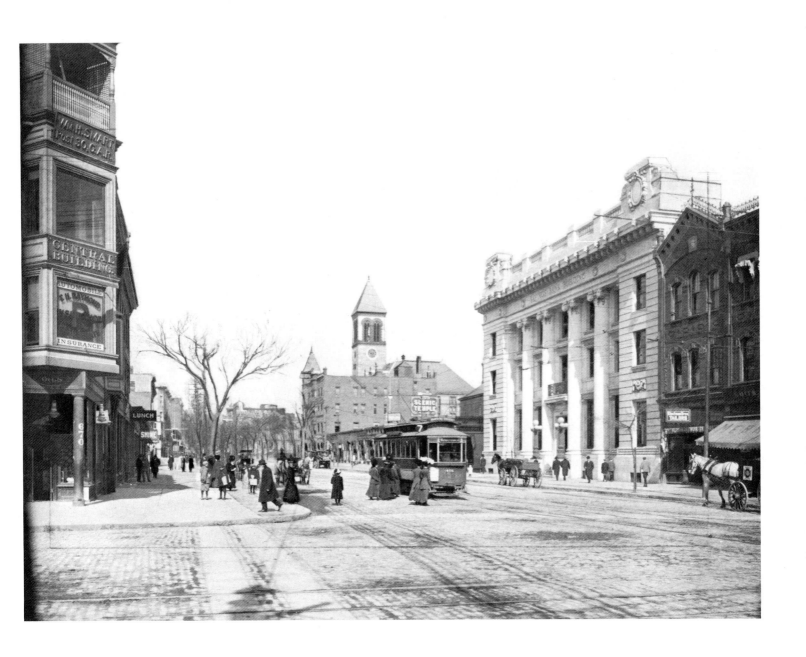

Cambridge, Massachusetts, circa 1908 Central Square was at this time Cambridge's central business district, located approximately halfway between Harvard and MIT. This perspective faces northwest along Massachusetts Avenue toward City Hall, whose clock tower is seen at center. The large edifice with Ionic columns is the Cambridgeport Savings Bank Building (1904). At extreme left is the Central Building.

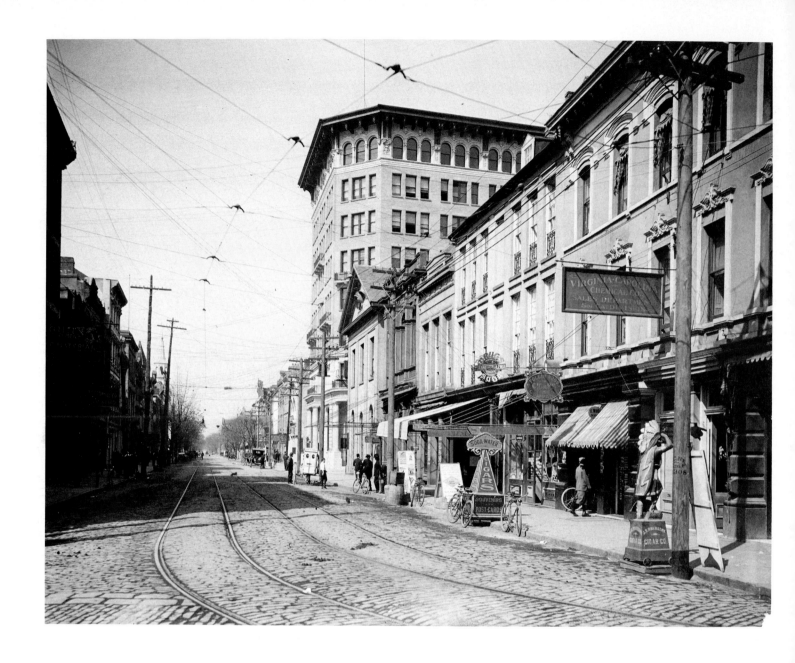

Charleston, South Carolina, circa 1900 This is a view down Broad Street, in the financial heart of Charleston. We are looking from the intersection with East Bay Street in a westerly direction toward (going west) State, Church, Meeting and King Streets and past them to Colonial Lake. The large building at center is the People's Building (18 Broad Street). Just east of that is the South Carolina National Bank (1817, and originally the Charleston branch of the Second Bank of the United States), with its pedimented front gable, which in 1855 was connected to the building at its right in this view. At extreme right is the Old Exchange Building (122 East Bay Street) and at extreme left is the former Walker-Evans Building.

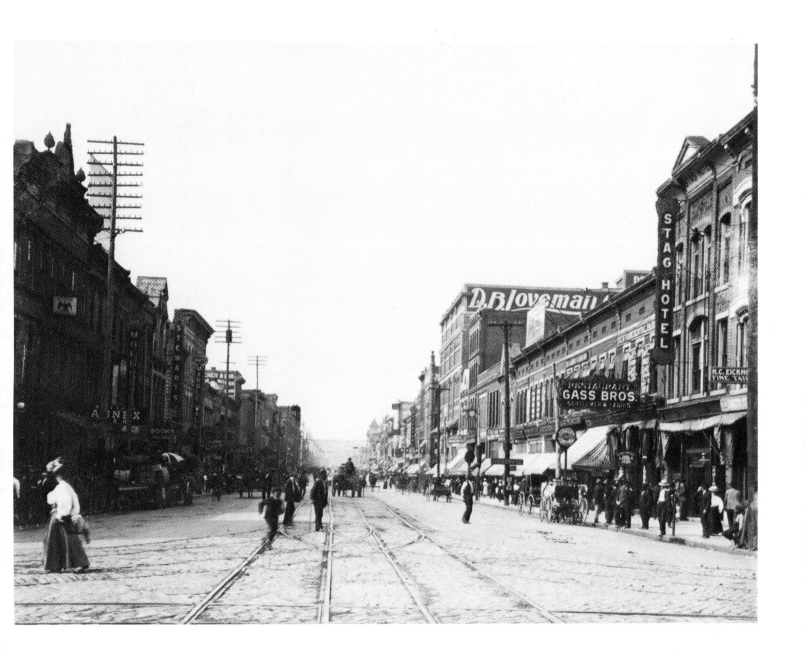

Chattanooga, Tennessee, 1907 Here is a view of Market Street looking north to the Tennessee River and Hill City (North Chattanooga) beyond. The camera was situated at the intersection of Market Street and Ninth Street. Of the firms pictured here, only D. B. Loveman Co., a dry-goods establishment (on the east side of Market Street, with its name in large white letters on the side of the building), and T. H. Payne & Co., stationers (the store with the "BOOKS" sign on the west side of the street), are still in business.

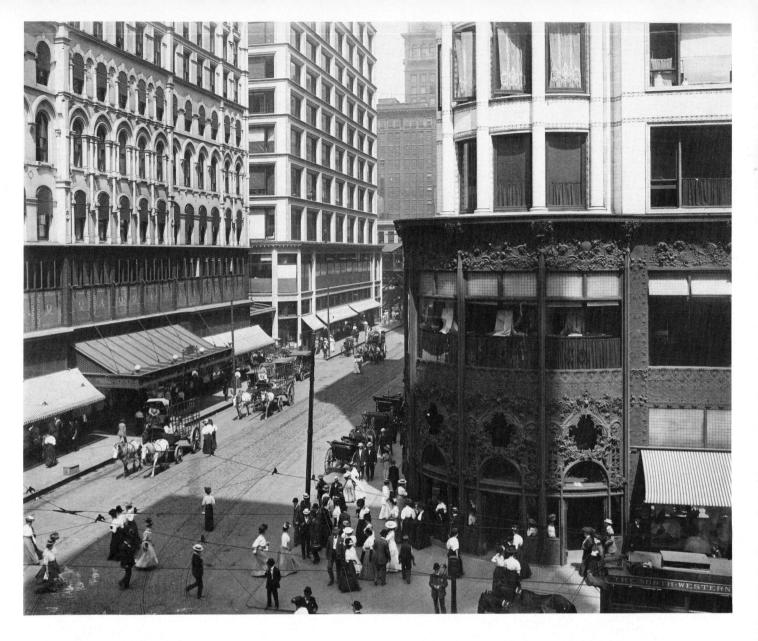

Chicago, Illinois, circa 1905 (ABOVE) The building at right is the Schlesinger & Mayer building, better known under its subsequent appellation, Carson, Pirie, Scott & Company. Built between 1899 and 1904, this was Louis Sullivan's final large-scale project and is often considered his finest architectural realization. The corner entrance is a marvel of intricate ironwork design. In this view the camera is on State Street looking east on Madison Street toward Wabash Avenue and the Loop elevated railway. On the left is Mandel Bros., which takes up a whole side of a block in two dissimilar though harmonious exterior styles.

Chicago, Illinois, 1900 (OPPOSITE) This was Chicago's "Theater District" at the turn of the century. We are looking east on Randolph Street from the vantage of LaSalle Street. From the left are the Powers Theatre, Sherman House, Clark Street and the Ashland Block. East of the Ashland Block is the relatively tall Schiller Building (1892, Adler and Sullivan; destroyed 1961), which housed the Garrick Theatre. From there, moving east: the Borden Block, Dearborn Street, the Real Estate Board Building (1874, Wheelock and Thomas), its upper corner lit by a band of light, and, a few doors east, the large, somewhat eclectic Masonic Temple. On the right edge of the picture is the City Hall and County Building (1882/1885–1906/1908). The architect for City Hall was John M. Van Osdel; J. J. Egan and Alex Kirkland were the architects for the County Building.

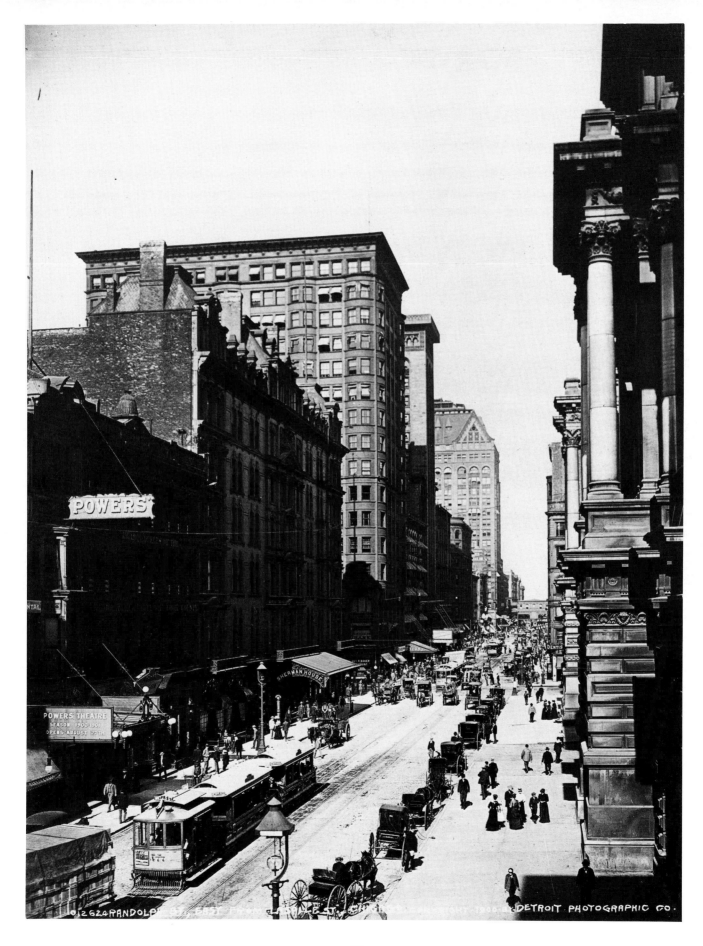

POWERS

POWERS THEATRE
SEASON 1900-1901
OPENS AUGUST 29TH

SHERMAN HOUSE

DETROIT PHOTOGRAPHIC CO.

23

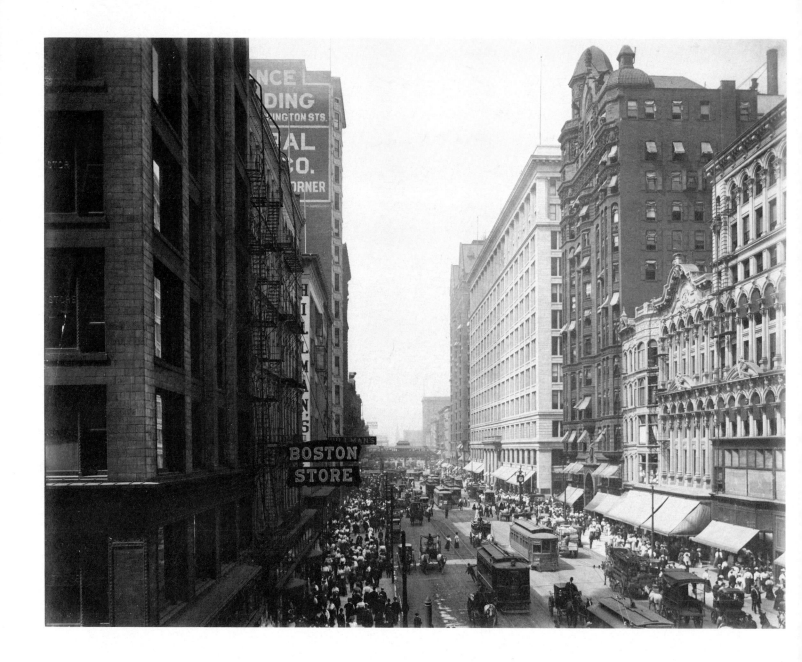

Chicago, Illinois, circa 1908 This retail-intensive artery is State Street, looking to the north from the intersection of Madison Street. At extreme left is the Champlain Building (1894, Holabird and Roche; demolished 1916). The large structure with "NCE DING" on its south side is the Reliance Building (1890, Burnham and Root, first two stories; 1895, D. H. Burnham & Co., top thirteen stories). At extreme right is Mandel Bros. and at center is the gleaming exterior of Marshall Field & Co. (1902, north section; 1907, south section; D. H. Burnham & Co.) soon after the addition of 1907. Across Randolph Street, just north of Marshall Field, is the Masonic Temple. The visible Loop elevated station is on Lake Street.

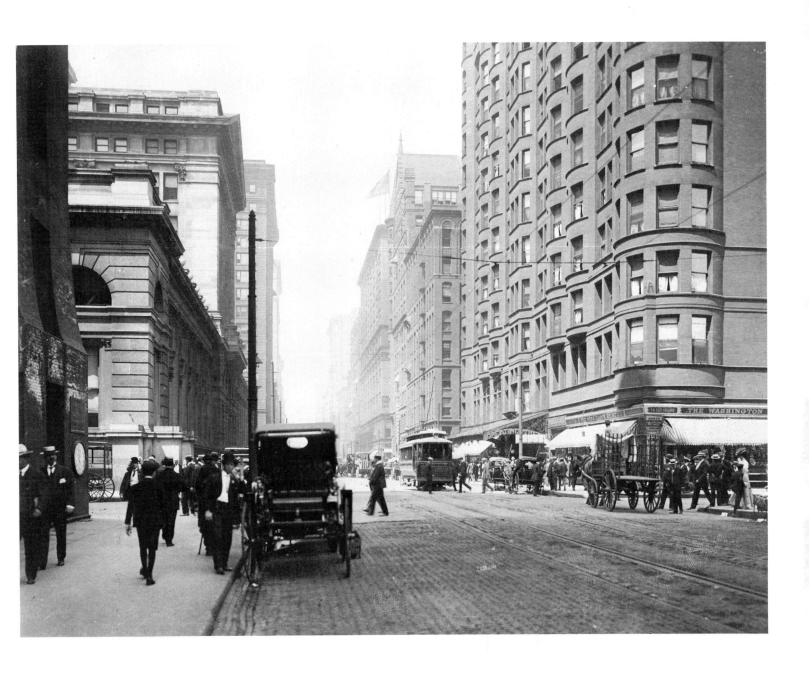

Chicago, Illinois, circa 1908 This photograph is looking north up Dearborn Street from just south of Jackson Boulevard. At extreme left is the northeast corner of the Monadnock Building (1891, Burnham and Root), Chicago's tallest and most massive wall-bearing structure. North of that is the Federal Building (1905, Henry Ives Cobb; demolished 1965), its tall pedimented center section flanked by lower wings. To the north of the Federal Building can be seen the southeast corner of the Marquette Building (1895, Holabird and Roche; notable for its Tiffany mosaics in the lobby) at the corner of Adams and Dearborn Streets. On the right edge of the picture is the Great Northern Hotel (1892, Burnham and Root; demolished 1940). At the center can be seen The Fair Store (1892, Jenney and Mundie).

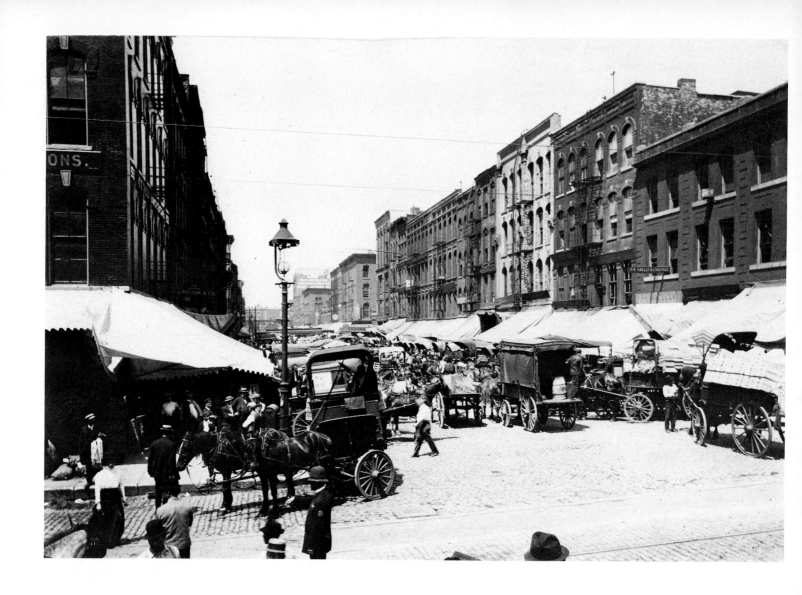

Chicago, Illinois, circa 1906 *(two views)* ABOVE: These are the horse-drawn carts of South Water Street Market. Near the Chicago River, this area was one of Chicago's primary food distribution points, dealing in fresh produce of all kinds.

OPPOSITE: The Loop elevated railway system, completed in 1897 and still in use today, "looped" around Chicago's central business district and defined within its circuit the zone of most ambitious vertical development. Here we are looking north up Wabash Avenue to the Madison Street Station of the Loop. The building on the left edge of the picture is Clifton House (1873, John M. Van Osdel; demolished 1927 to make way for the expansion of Carson, Pirie, Scott & Company). Just to the north is the Church Building (1903, Hill and Woltersdorf), now part of Carson's, and, north of that, the J. P. Atwater Building, also incorporated into Carson's. Toward right center is the white hull of Mandel Bros., and beyond that the half-developed form of Marshall Field's.

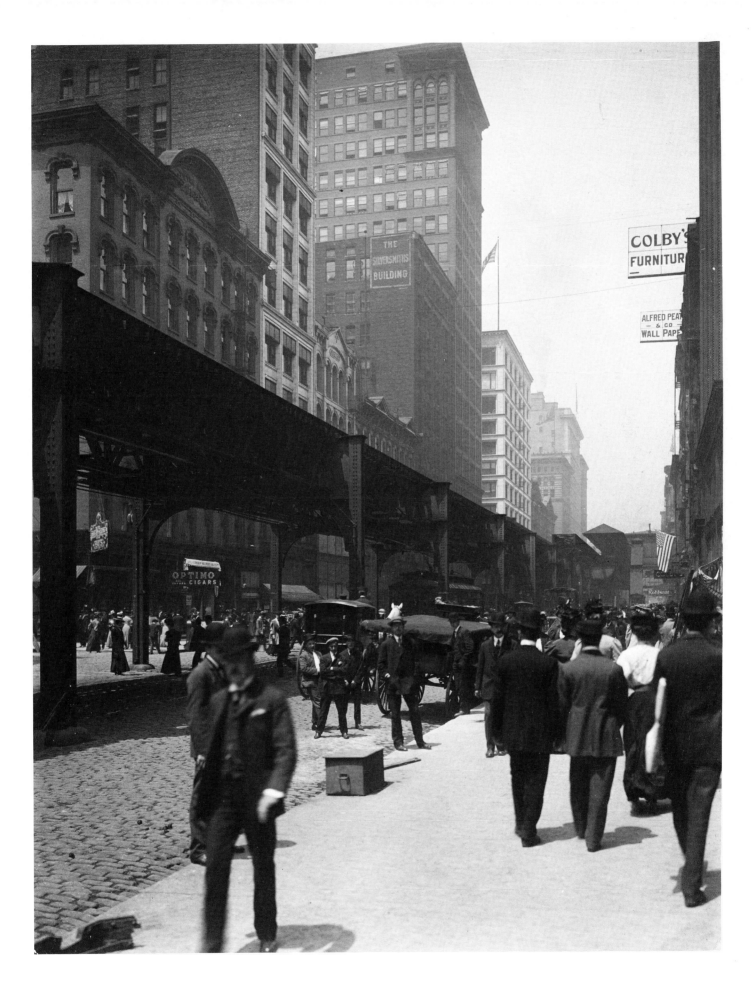

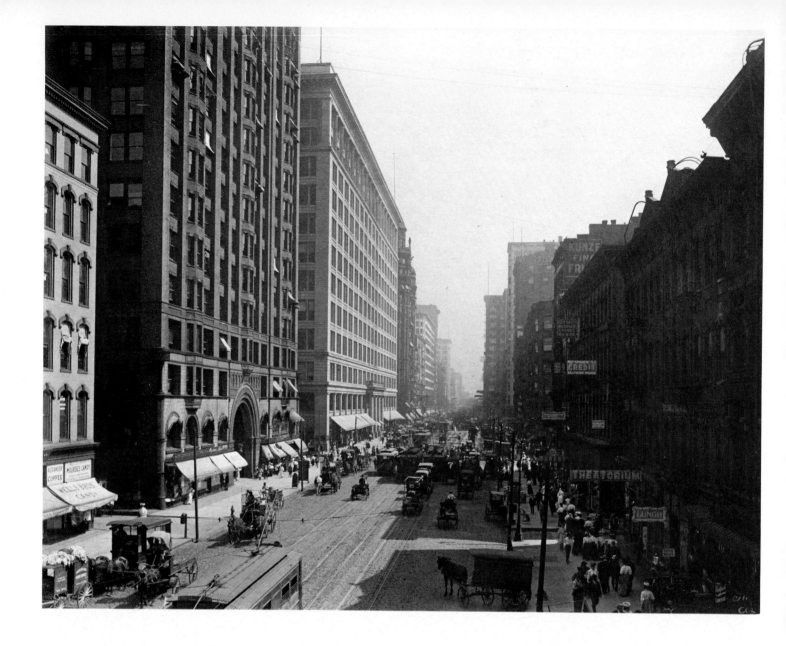

Chicago, Illinois, circa 1900 (ABOVE) Here is a busy corner of Chicago's "Loop" business district. We are looking south down State Street from a vantage point just south of Lake Street. The first crossing (foreground) is with the alley between Lake Street and Randolph Street. South of this alley (left) is the Masonic Temple, with its Romanesque entrance arch, and south of that is Randolph Street. South of Randolph Street is Marshall Field & Co.

Cincinnati, Ohio, circa 1917 (OPPOSITE) Main Street, with its trolleys and carriages, stretches off to the north in this perspective. The foreground thoroughfare, running right to left, is Fifth Street. The center building, with the squarish little tower, is the Gwynne Building, located on the corner of Sixth and Main Streets. It was built in 1914. On the left edge of the picture is the old Federal Building and Post Office, which has its main entrance on Fifth Street. The tall structure a few doors to the left of the right edge of the picture is the Blymyer Building, with its directory displayed on its south wall.

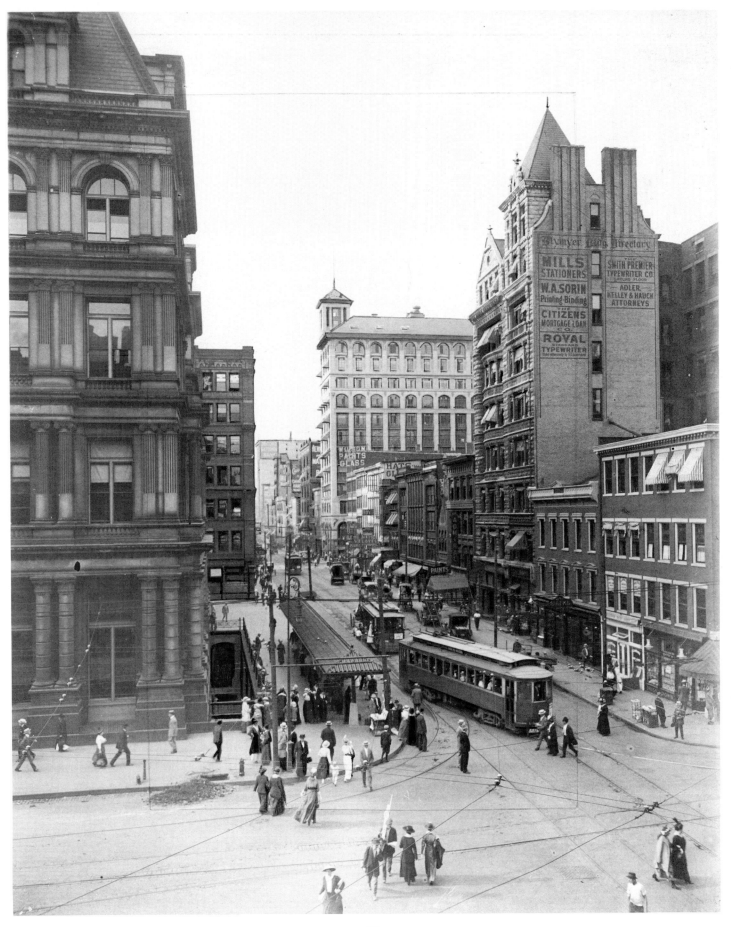

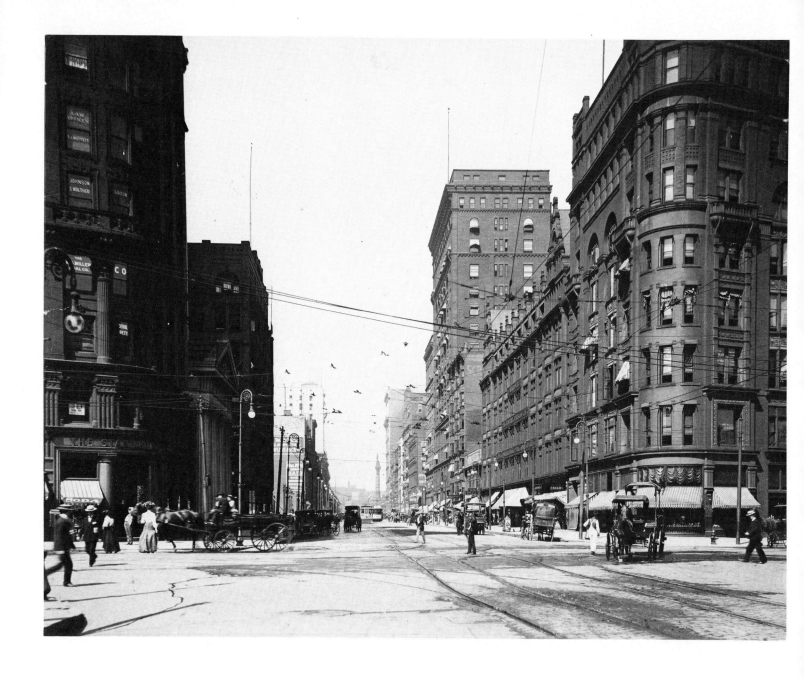

Cleveland, Ohio, circa 1906 This was, as it remains to this day, a banking and commercial district, the financial heart of Cleveland. We are looking west on Euclid Avenue toward Public Square with its 125-foot soldiers' and sailors' monument. East 9th Street runs from left (south) to right (north) across the foreground. The Hickox Building is on the right edge of the picture. The tall edifice about midway from there to Public Square is the New England Building. The Schofield Building is at the left edge of the picture and just to the west of it is the Citizens Building.

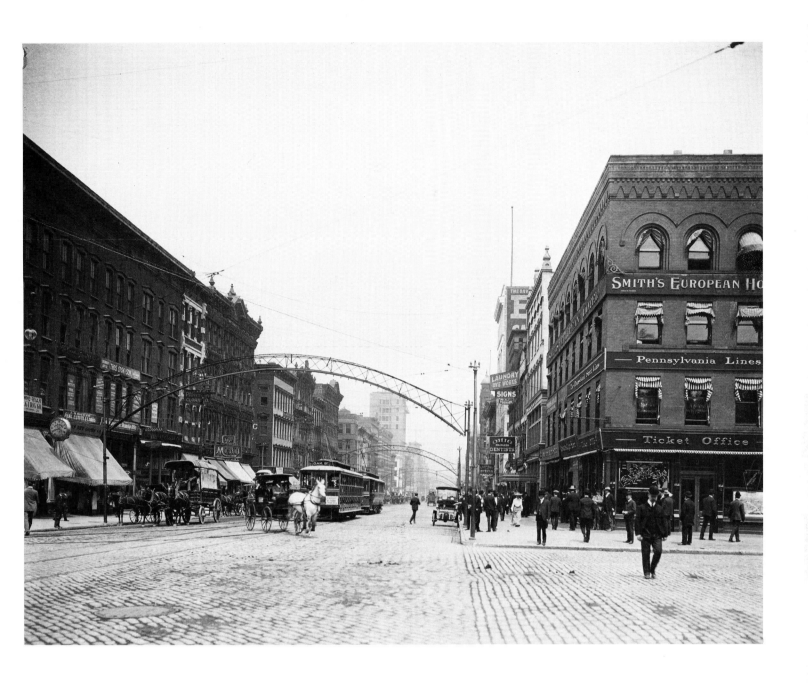

Columbus, Ohio, 1903 This is the best-known intersection in Columbus, the crossing of East Broad and North High Streets. Here we are looking north on High Street from the vantage of East Broad. Heading north from this point, one crosses Gay Street and then Long Street. The buildings seen on the block at left formed the Deshler Block, owned by the entrepreneurial Deshler family. The car parked beneath the illuminating span was the first in Columbus, having been driven from Cleveland on June 9, 1899 by Campbell M. Chittenden. The building at the right of the picture, Smith's European Hotel, also housed offices of the Pennsylvania Lines. Today, this building is known as the Roy's Jewelers Building, and has been vacant since the early 1980's.

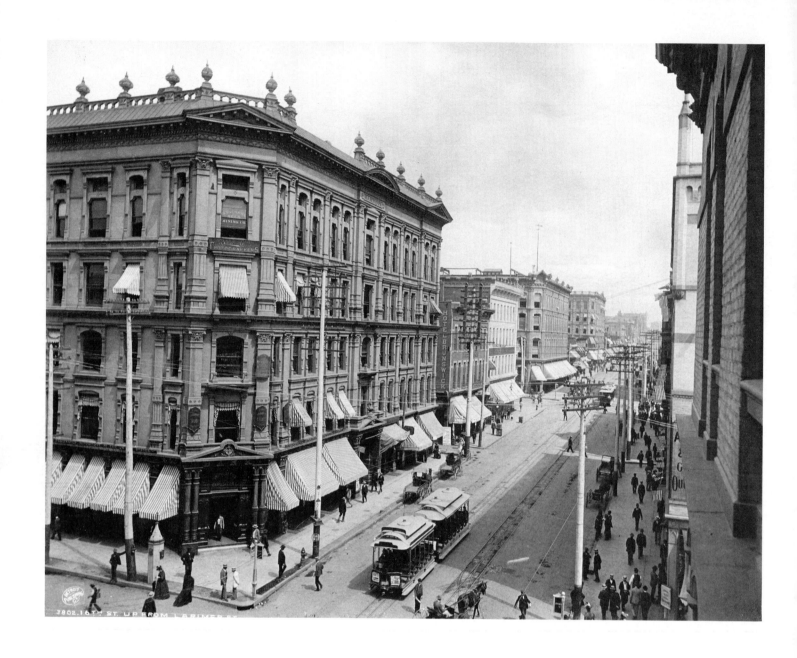

Denver, Colorado, circa 1890 This photograph by the renowned William Henry Jackson shows 16th Street receding off toward the northeast from the position of the camera. This street has been, historically, Denver's main commercial artery in the downtown area. The cross street on which the viewer is situated is Larimer Street and the next street up to the northeast is Lawrence Street. At the left is the Tabor Block (destroyed 1972), erected by bonanza king and six-week senator H. A. W. Tabor, whose lavish outpouring of funds was instrumental to Denver's metamorphosis from town to city. Tabor was also responsible for the opulent Tabor Grand Opera House. The trolleys visible here were part of the Denver City Cable Railway.

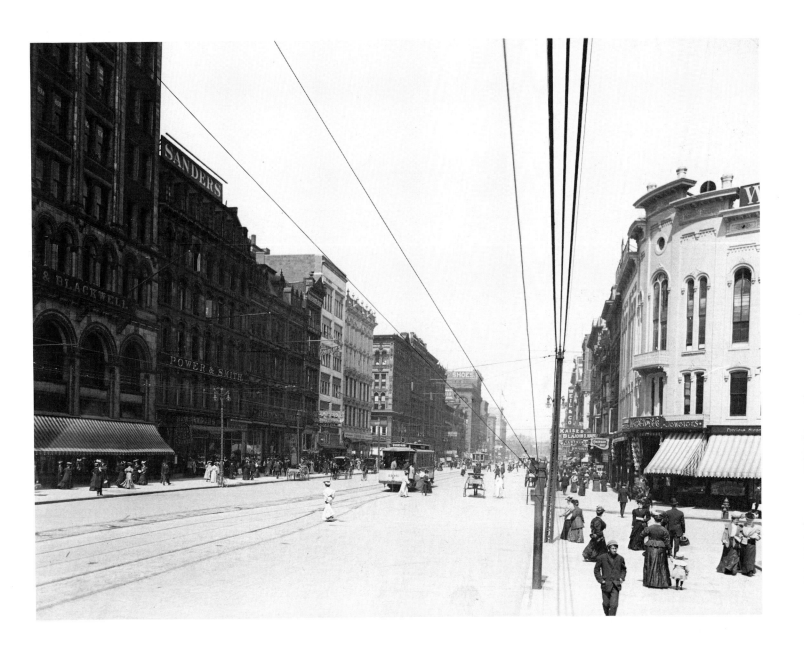

Detroit, Michigan, circa 1910 Here we are looking up toward the north along the broad vista of Woodward Avenue, Detroit's main street. Woodward Avenue is named for Augustus B. Woodward. Woodward headed the reconstruction of Detroit, following the fire of 1805 (which completely leveled all but one of Detroit's buildings), basing his design on one by L'Enfant, who provided the basic plan (with its wide avenues and open expanses) of Washington, D.C. Detroit's downtown area is still built on Woodward's layout, with Woodward Avenue being the central axis.

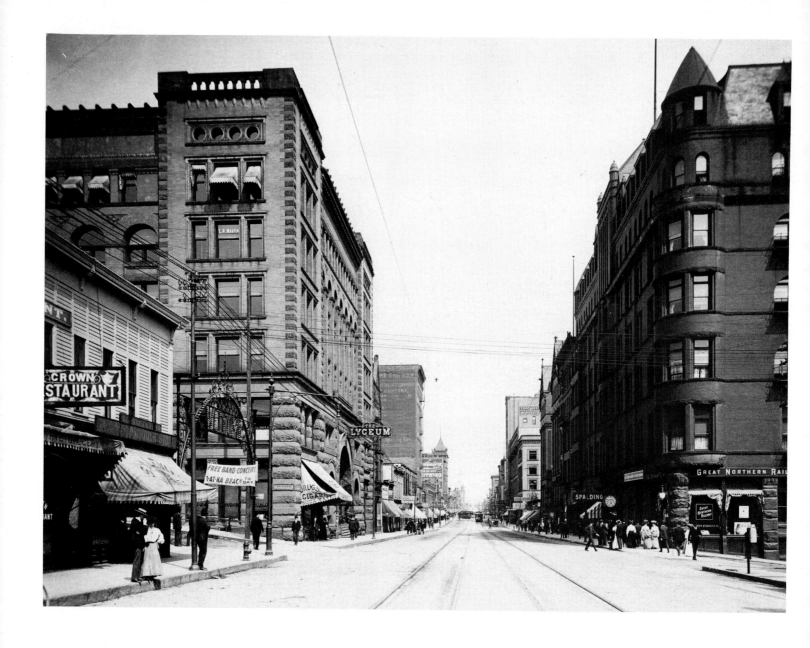

Duluth, Minnesota, circa 1909 West Superior Street proceeds east from the gaze of the camera. The Crown Restaurant (at left) was replaced in 1915 by the Holland Hotel. To the east of that is an ironwork gate on Fifth Avenue West (the intersections to the east are Fourth Avenue, Third Avenue, etc.) bearing ornamental scrollwork. The Lyceum (1891, Oliver Traphagen and Francis W. Fitzpatrick), at center left, was Duluth's most impressive theater. This Romanesque structure combined the functions of office building with those of theater. The Lyceum had the second largest stage in the Northwest, after Adler and Sullivan's Auditorium in Chicago. Across West Superior from the Lyceum is the Spalding (1889). James J. Egan was the architect for this important Duluth hotel, designed in the Romanesque style. The Lyceum and the Spalding were demolished in the 1960's.

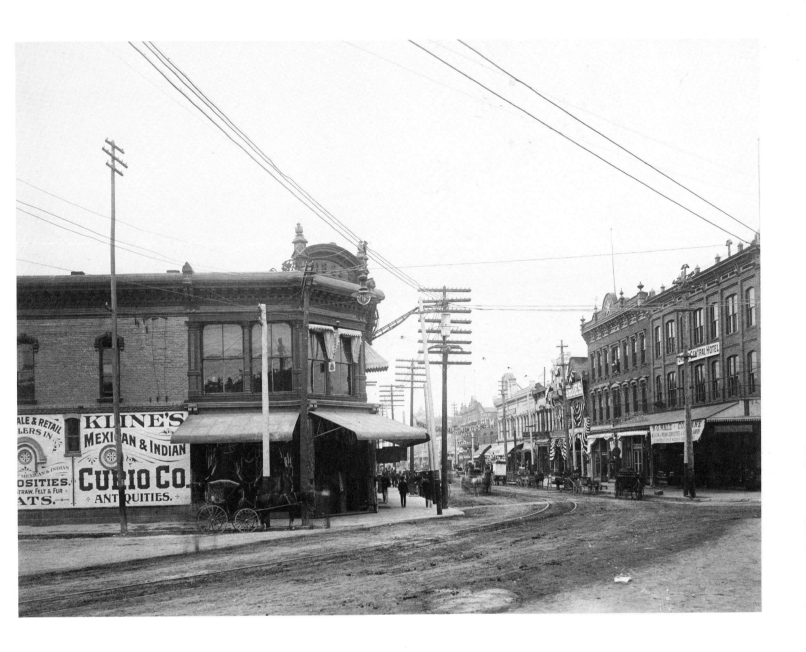

El Paso, Texas, 1903 This perspective shows South El Paso Street's 100 block looking to the south. The building at left, twenty years old at the time of the photo, featured Kline's curio shop. The two buildings at the extreme right were razed during the mid-1980's to allow for the expansion of the Paso del Norte Hotel. At the time of the photograph the depicted area was the business center of El Paso, although that hegemony slipped away in the subsequent decade.

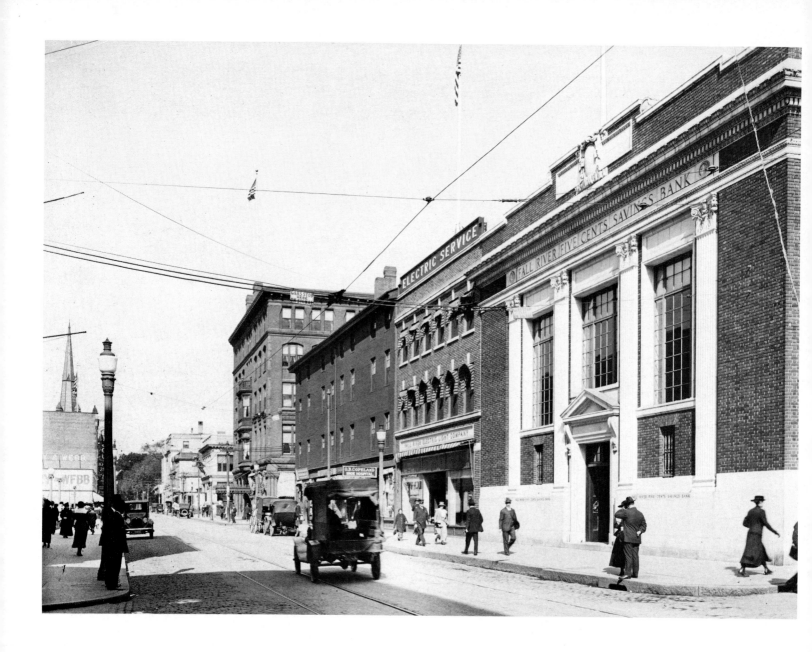

Fall River, Massachusetts, circa 1916 Here is Fall River's North Main Street looking north. The foreground cross street is Bank Street, and the next one further north is Franklin Street. At the right of the picture is the Fall River Five Cents Savings Bank (1915, still standing). To the left of that is the Fall River Electric Light Company (still standing, but now the Fall River news bureau of the *Providence Journal*). The third building from the right, which housed a number of enterprises, was razed in 1987 to be replaced by an office building. The fourth building from the right was the Hotel Mellen, which was bought by the city in the early 1960's for use as a city hall. It was demolished in 1976. At the left of the picture is Cherry and Webb Co., a women's clothing store, which removed from this location in 1917.

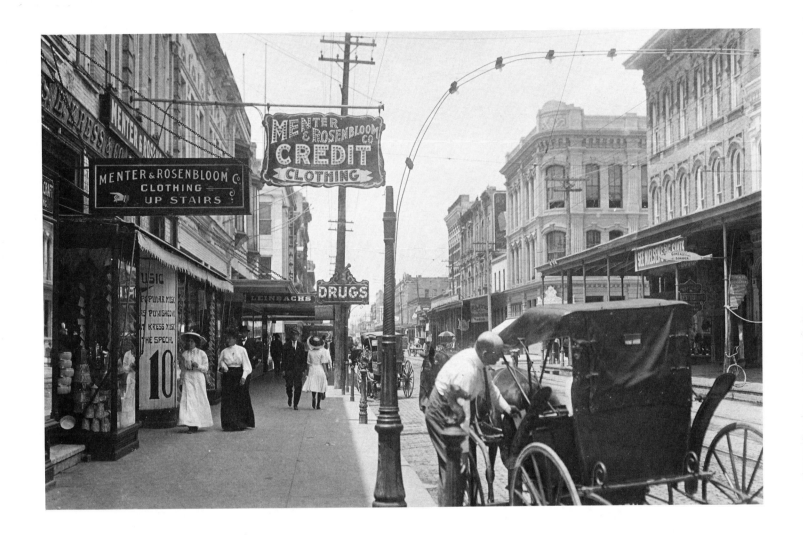

Galveston, Texas, circa 1908 In this view we are looking west on Market Street (also known as Avenue D). At left (2117 Market Street) is a branch of Menter & Rosenbloom Company, a New York-based shoe and clothing store chain, located there between 1906 and 1910. Just past Menter & Rosenbloom is the pharmacy of George F. Leinbach (2121 Market Street). On the opposite side of the street is Gonzales & Schaper (2122 Market Street), with its fish-shaped sign, which sold sporting goods and ammunition. Just to the north one can see the intersection with 22nd Street. At the time of this photograph Galveston was virtually midway between two devastating hurricanes: the hurricane of 1900, in which 6000 Galvestonians lost their lives, and the hurricane of 1915, which claimed 275 fatalities.

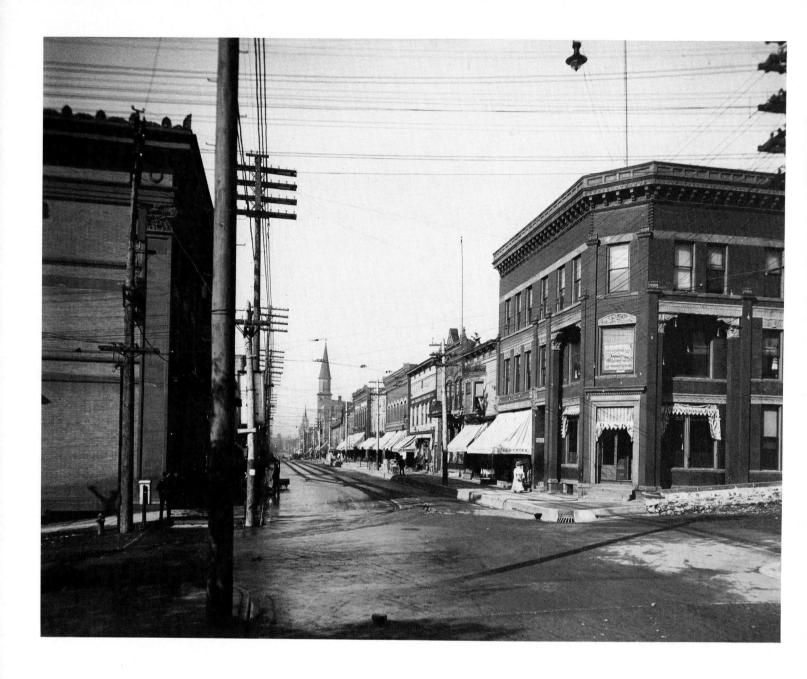

Hancock, Michigan, circa 1900 This downtown Hancock photograph was taken at the intersection of Quincy and Reservation Street and looks down Quincy toward the west. The building at extreme right is the Kukkonen Building. At extreme left is the Superior National Bank Building. The large steeple at center belongs to St. Patrick's Catholic Church, and the much smaller one to its left is St. Joseph's Catholic Church. At center (at a 30° angle to the right from the top of St. Patrick's spire) is the Northwestern Hotel.

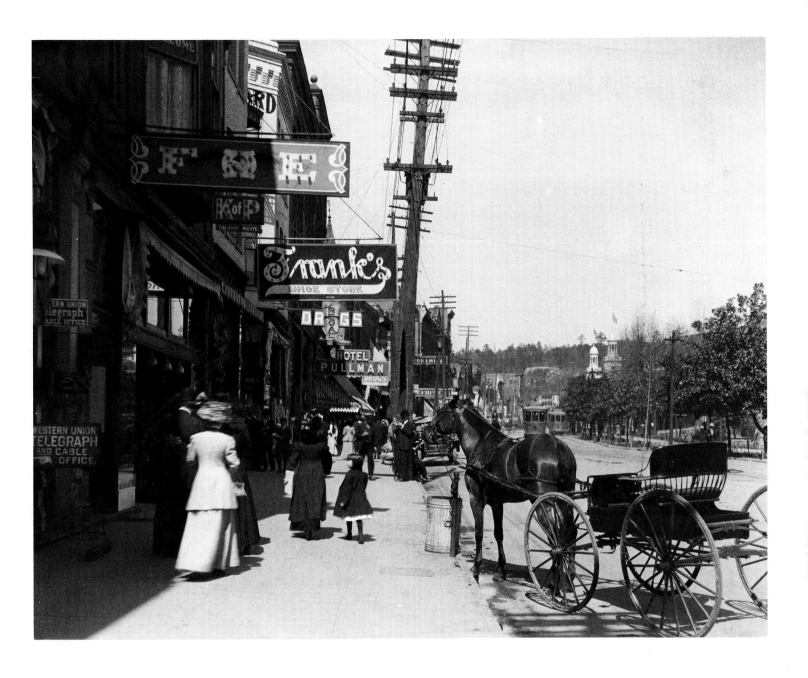

Hot Springs, Arkansas, circa 1890 This is the renowned "Bath House Row" of Hot Springs, which attracted visitors from around the country in search of the beneficial properties of the mineral baths. The avenue we are looking up is Central Avenue (facing north). Bath House Row is hidden among the trees on the right, from which the towers of the Arlington Hotel rise. The Arlington has since burned down, and was rebuilt across Fountain Street to the north. The south side of Fountain is now part of Hot Springs National Park.

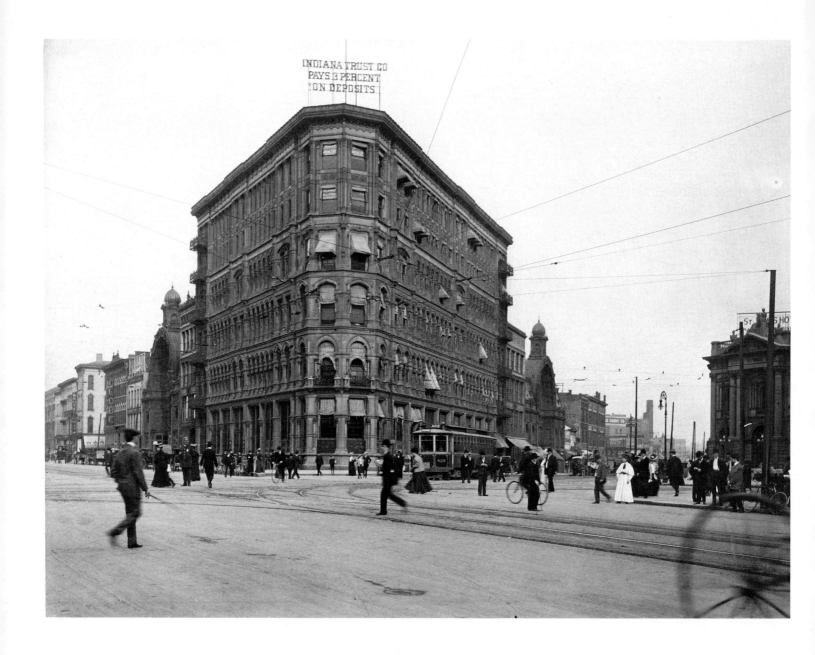

Indianapolis, Indiana, circa 1900 This was downtown Indianapolis at the turn of the century. The road that goes from the extreme right to the left edge of the picture is Washington Street, which moves off to the east as one goes toward the left edge. The street with the trolley intersecting Washington is Pennsylvania Street, and here we are looking down Pennsylvania toward the south. The large building in the center is the Indiana Trust Co., and flanking it on either side is the Lincoln Arcade with its arched entrances and cupolas. The building at extreme right is the Old Indiana National Bank.

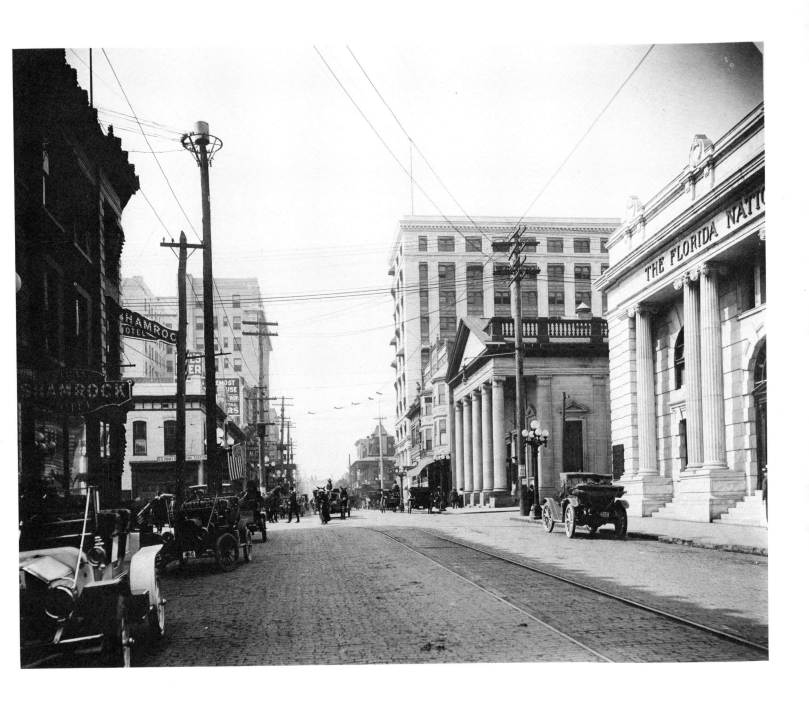

Jacksonville, Florida, circa 1911 The camera faces west on Forsyth Street. The nearest visible intersection is with Laura Street. On the northeast corner of this intersection is The Florida National Bank; on the northwest corner is the Barnett Bank; the Shamrock Hotel is located near the southeast corner; and on the southwest corner is the U.S. Army Recruiting Station.

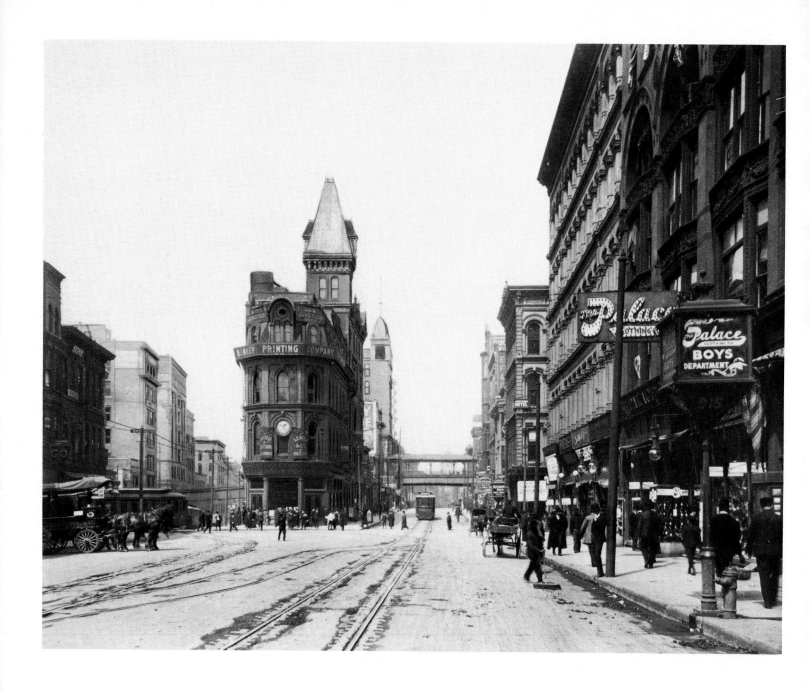

Kansas City, Missouri, circa 1905 The conspicuous building at the center of the photograph is the Junction Building, so named because of its location at the junction of 9th, Main and Delaware Streets, the city's busiest intersection at the time, which was known simply as the "Junction." In its time the Junction Building housed numerous businesses, among them a newspaper, a business college and a hotel. The view here is looking north on Main Street toward 9th Street from (approximately) 10th. Delaware Street forks off to the left from Main Street at 9th.

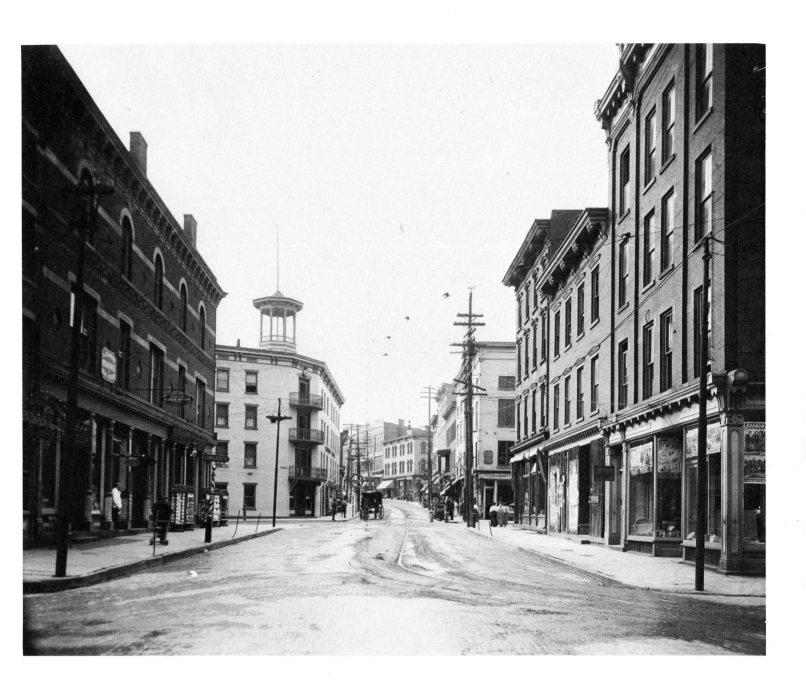

Kingston, New York, circa 1900 This was the focus of the Rondout commercial district of Kingston, a shipping and boatbuilding center through the nineteenth century. The area's business activities continued virtually unabated into the twentieth century but dropped off in the 1950's and 1960's. In the 1970's Urban Renewal extirpated all structures to the east of Broadway (the street one is looking down in this view). Only two buildings in this photograph still remain (though perhaps the most notable ones, fortunately): the Freeman building (at far right), originally the Sampson Opera House and built in 1875 in the Italianate style, which at the time of the picture housed the Sampson and Ellis store and later the Kingston Freeman newspaper; and Mansion House (1854), built by Major George Von Beck, a luxury hotel in its time, whose distinctive cupola has since been lost.

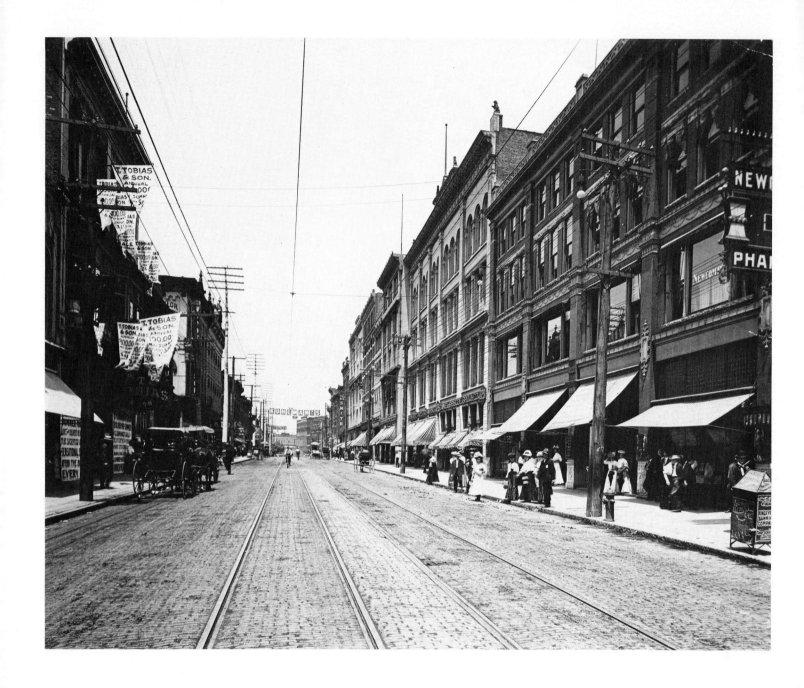

Knoxville, Tennessee, circa 1908 This was the main commercial district of Knoxville in the nineteenth and early twentieth centuries. In fact, this street, Gay Street (here looking north from near Commerce Avenue), was Knoxville's most important thoroughfare of commerce. The most prominent business establishments of the city were set up along this road. Interestingly, Gay Street was named after the street of the same name in Baltimore, Maryland.

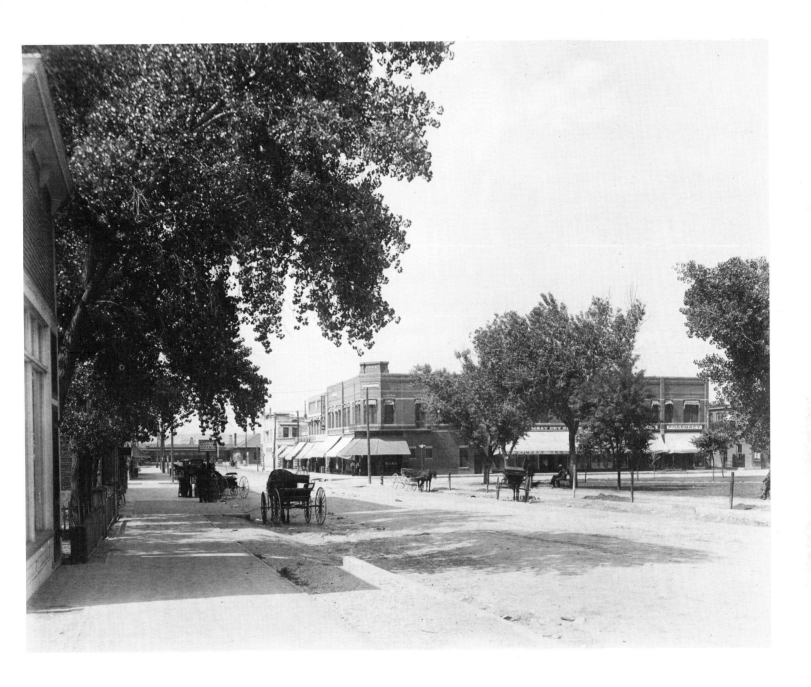

La Junta, Colorado, circa 1908 Here is the mercantile heart of La Junta, southeast of Pueblo. The camera was placed on the west side of Santa Fe Avenue, facing toward the north. The pastoral corner at right is Centennial Park. Passing along the north side of the park is Second Street, and, moving north on Santa Fe Avenue, the next intersection up is that with First Street. The building at center on the corner of Santa Fe and Second is the Finney-Albera Building (1898, still standing), the second floor of which was added in 1906 to accommodate the Sherman House Hotel. Santa Fe Avenue comes to an end at First Street; the north side of the latter is the Atchison, Topeka and Santa Fe Railway depot.

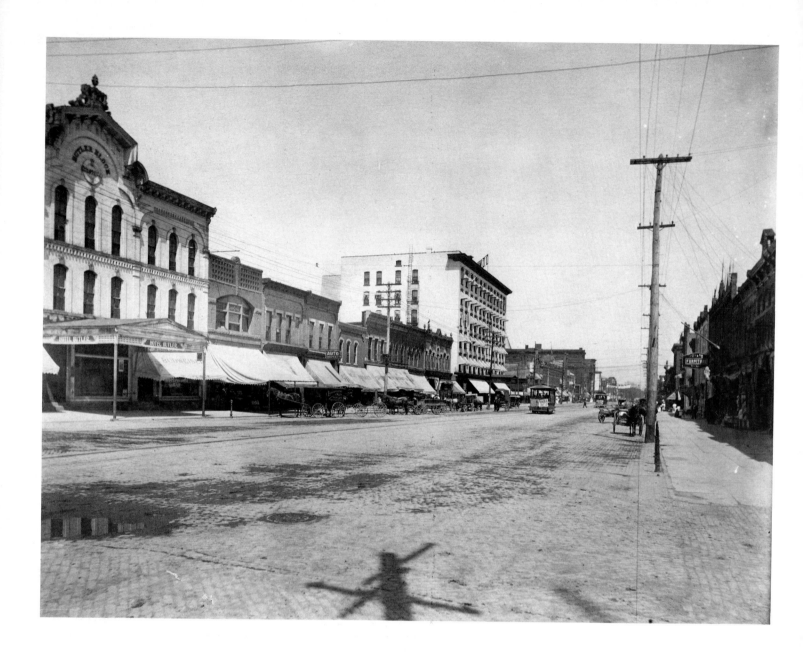

Lansing, Michigan, circa 1909 Michigan's capital city is viewed here after the turn of the century, showing Washington Avenue facing north from the intersection of Kalamazoo Street toward Washtenaw Street. At extreme left is the Butler Block (1872; destroyed in 1950), built with bricks from the Old State Office Building (which was taken apart to make room for the present Capitol). The other large edifice (at center) is the Hotel Downey (1866, also known as Downey House) at the corner of Washington and Washtenaw. Often referred to as Michigan's "unofficial capitol," Downey House was originally Lansing House but changed its name when purchased in 1888 by H. P. Downey. Downey House survived a number of fires and renovations, only to be demolished in 1936.

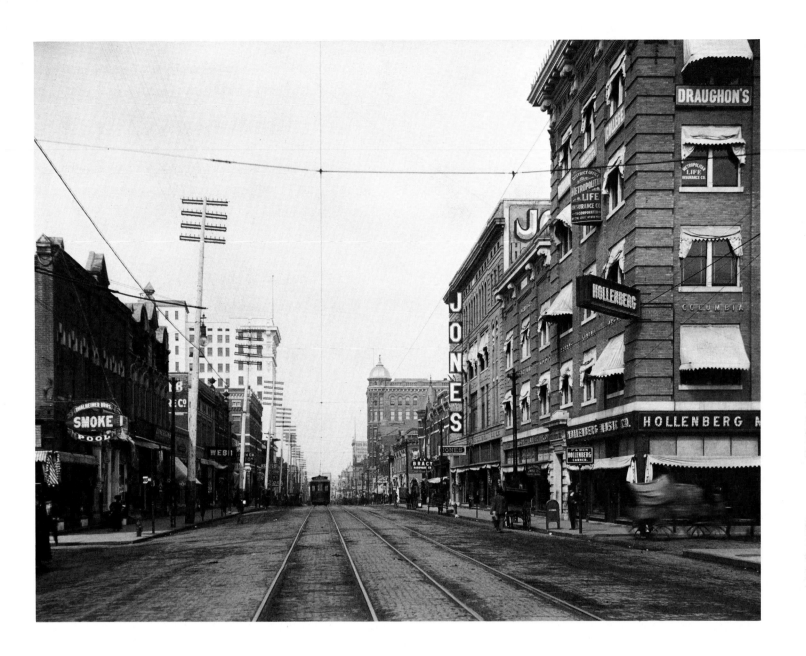

Little Rock, Arkansas, circa 1910 This was downtown in the capital of Arkansas. Here we are looking north on Main Street from just south of 7th Street (the next street north is 6th Street). At extreme right is the Hollenberg Building, which housed a number of firms, including the Hollenberg Music Co. and Draughon's Practical Business College. Just north of that is the Jones House Furnishing Company (609–615 Main), and, north of that, the E. D. Bracy Hardware Company. On the west side of Main (extreme left) is Thalheimer Brothers (624 Main), offering tobacco products and billiards. Further north, at 608–610 Main, is W. W. Webb Furniture.

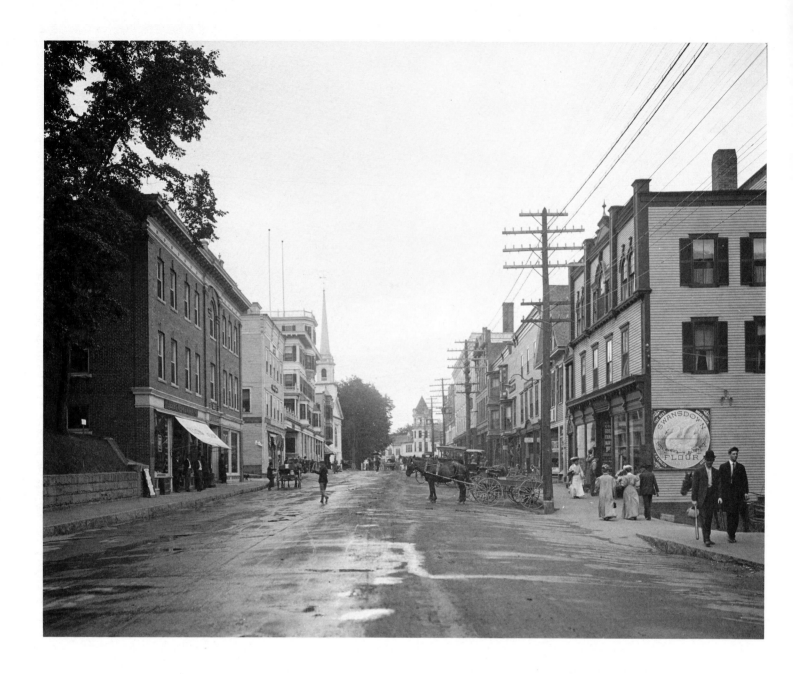

Littleton, New Hampshire, circa 1908 The focus of this view is the combination opera house and town hall with its notable tower (at center), built in 1895 (Howard and Austin). The view shows Main Street looking east toward the town hall. At extreme left is the Kilburn building (circa 1901), built for Benjamin Kilburn, the renowned stereo-view manufacturer. Just to the left of the large tree at center is the Methodist Church (1850), built in the Greek Revival Style.

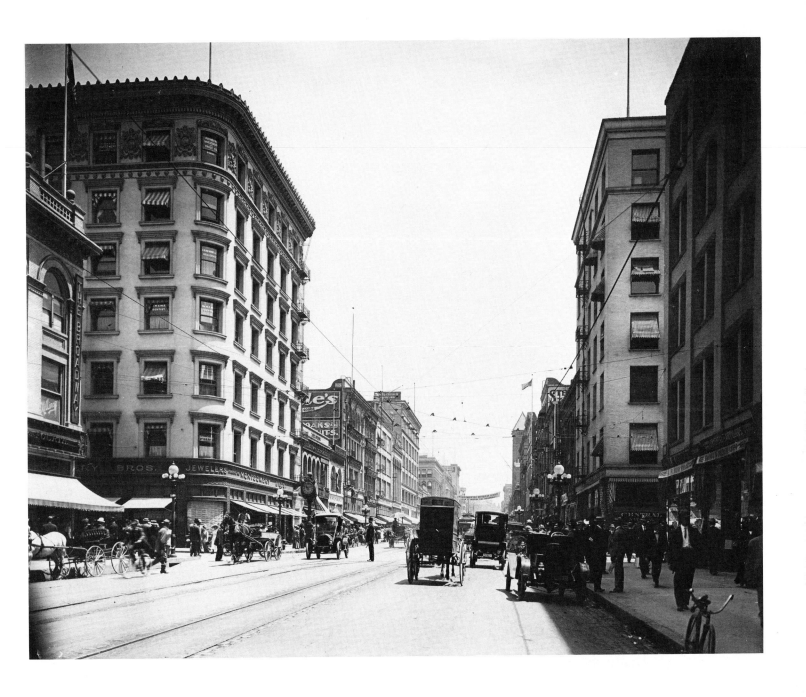

Los Angeles, California, 1911 This is Broadway looking north toward 4th Street (first visible cross-street), and past that to 3rd, etc.. At extreme left is The Broadway Department Store. At center can be seen the sign atop the Homer Laughlin Building. Stretched across Broadway is a political banner that effectively dates this scene. The banner is an advertisement for gubernatorial candidate Hiram Johnson.

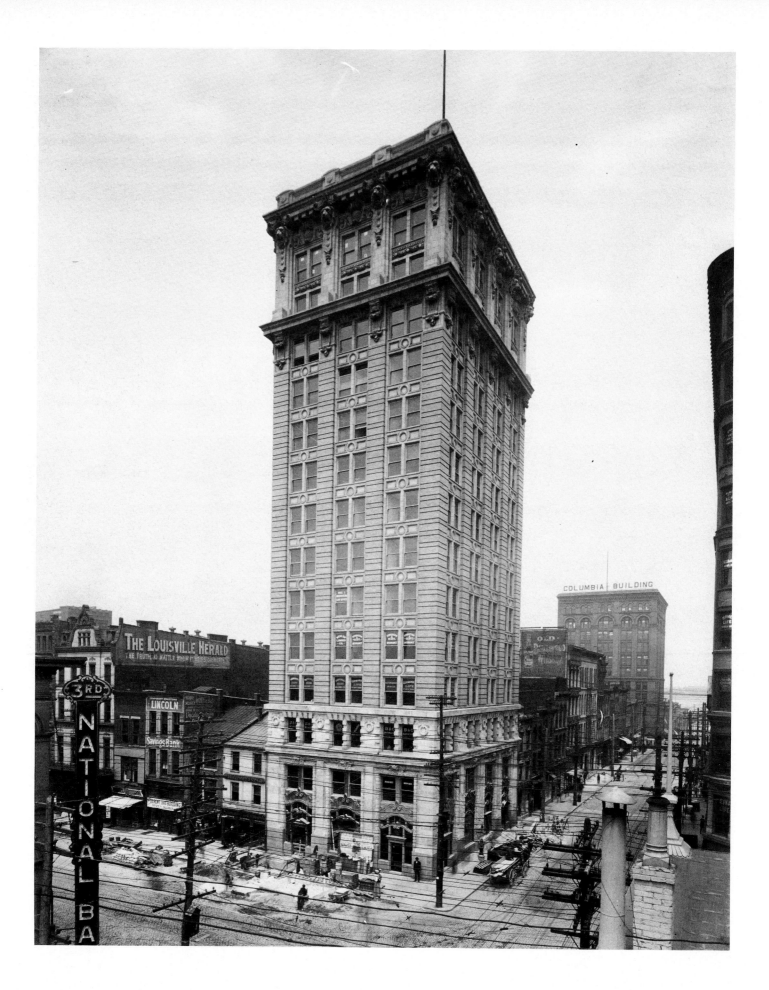

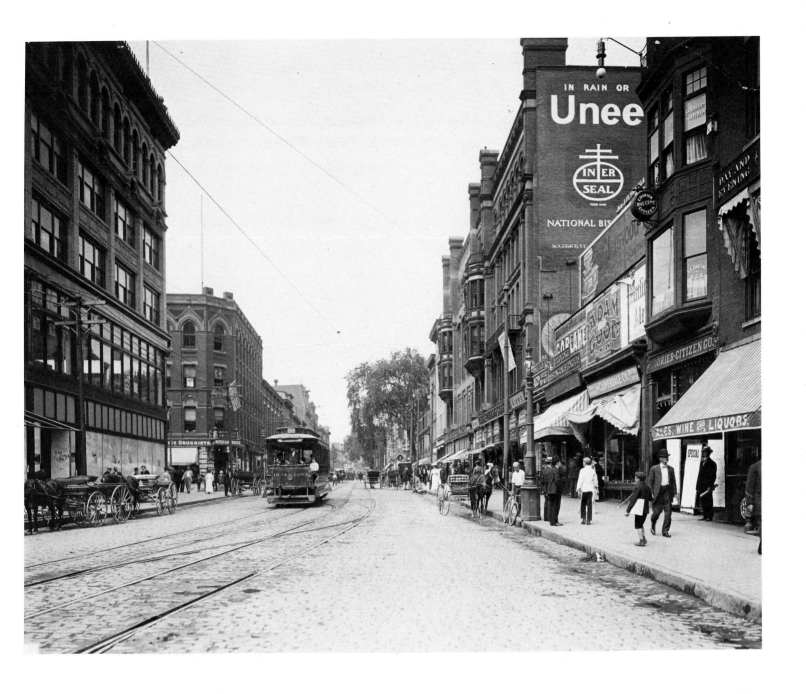

Louisville, Kentucky, 1906 (OPPOSITE) This photograph is dominated by the Lincoln Savings Bank, captured at a moment very near its completion. After a number of transmutations, Lincoln Savings Bank is still in operation as the First National Bank of Louisville. Looking up Fourth Street (at right) one faces north to the Ohio River. Visible at Fourth and Main Streets is Louisville's first skyscraper, the Columbia Building (1889). The street running from east to west (in the foreground) is Market Street.

Lowell, Massachusetts, circa 1895 (ABOVE) Here is downtown Lowell toward the end of the nineteenth century. At extreme left is the Chalifaix Building and to its right is the Wyman Exchange. The thoroughfare at center is Merrimack Street, looking to the northwest. The building with the Uneeda advertisement on its side is the Hildreth Block.

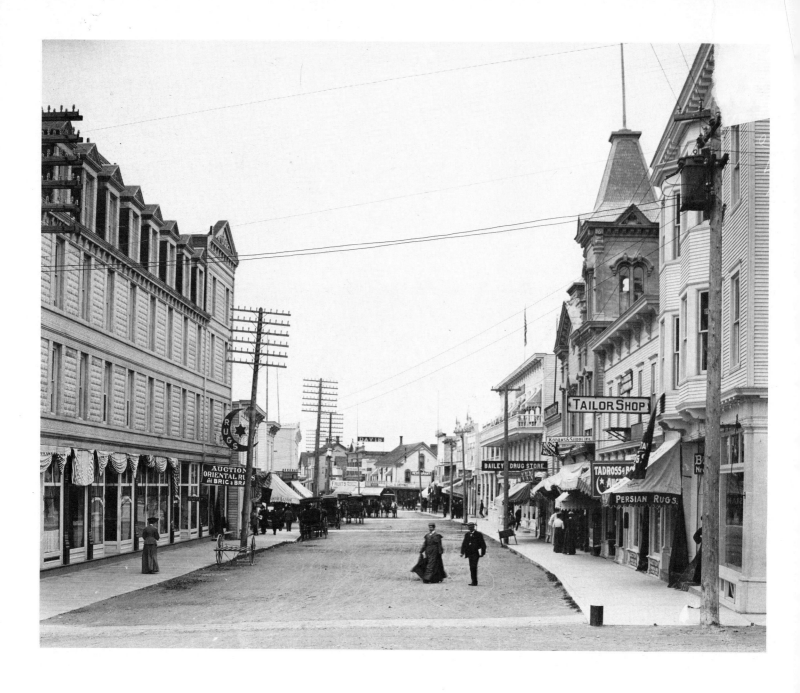

Mackinac Island, Michigan, 1910 This Lake Huron island has been a historic strategic point for France, Britain and the United States, and was the headquarters for the American Fur Company owned by John Jacob Astor. The island is now a state park from which automobiles are excluded. The photograph shows Main Street looking west. At extreme left is the Chippewa Hotel. By 1910 Mackinac Island was already developed as a resort.

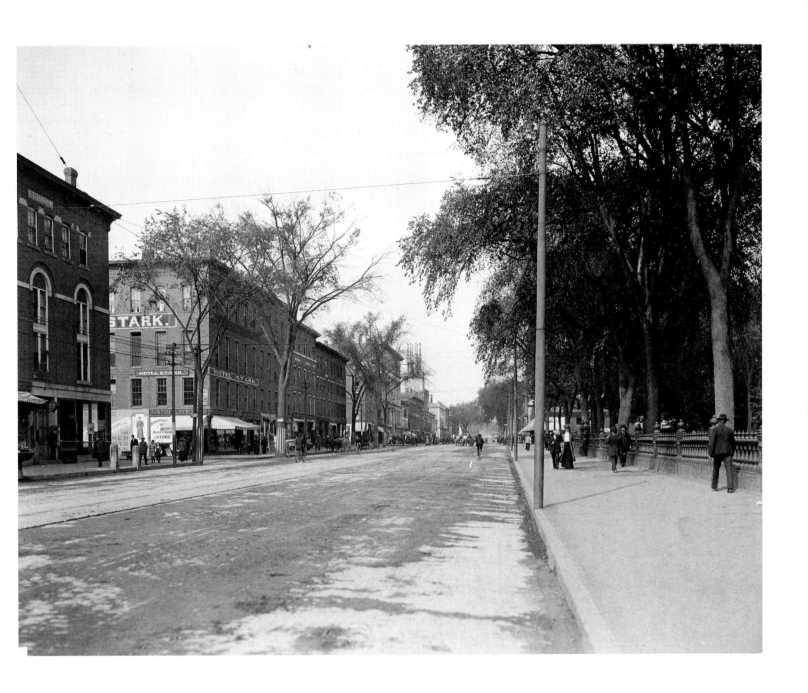

Manchester, New Hampshire, circa 1910 Most of the buildings shown here (except for the elegantly spired City Hall at center) have been replaced with high-rise structures. The street is Elm Street (the "main street" of Manchester) looking toward the northwest. At extreme left is the Green Block and north of that, Pleasant Street, across which is the Hotel Stark (sharing its structure with Boston Clothing Co.). At extreme right is Merrimack Common, restored and renamed Veterans Memorial Park in 1985. Elm Street is now the financial zone of Manchester, the merchants having since flown to suburban malls.

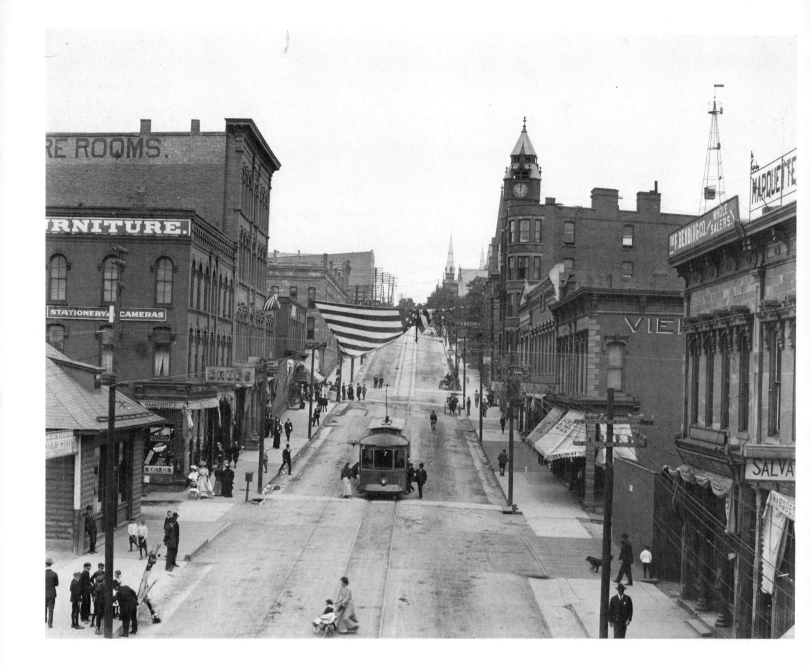

Marquette, Michigan, circa 1905 This is Front Street looking north up the hill in the direction of Ridge Street, at the corner of which (center) can be seen the spires of the Methodist Church. The large clock tower on the east side of the street belongs to the Savings Bank Building. On the northeast corner of the intersection with Main Street is the Vierling saloon; on the southeast corner is the F. Bending Company (wholesalers of tobacco and alcohol); on the southwest corner is the Duluth, South Shore and Atlantic Railway Company Passenger Station; on the northwest corner is the Stafford Drug Company. The intersection north of Main Street is with Washington Street.

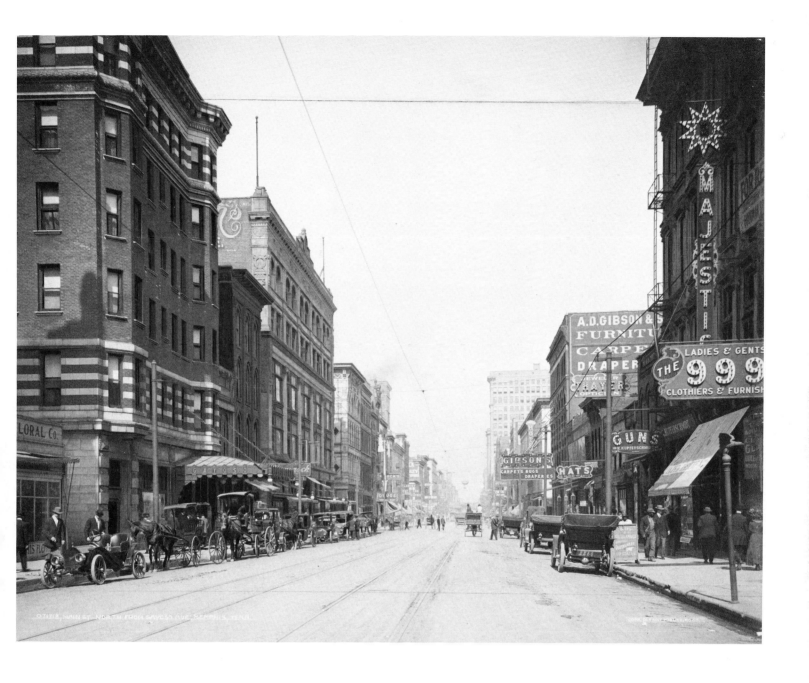

Memphis, Tennessee, circa 1912 The "Hub of Memphis" at the time, this was South Main Street (facing north from a point just north of Beale Street). At left is the stone and brick edifice of the Hotel Gayoso, the oldest sections of which were built before 1860. The Gayoso was headquarters for a number of generals on both sides during the Civil War. On the right is the sign of the Majestic Theatre, as well as those of R. Kupferschmidt & Company Guns, Brown Hat Company, and A. D. Gibson & Sons Furniture Company.

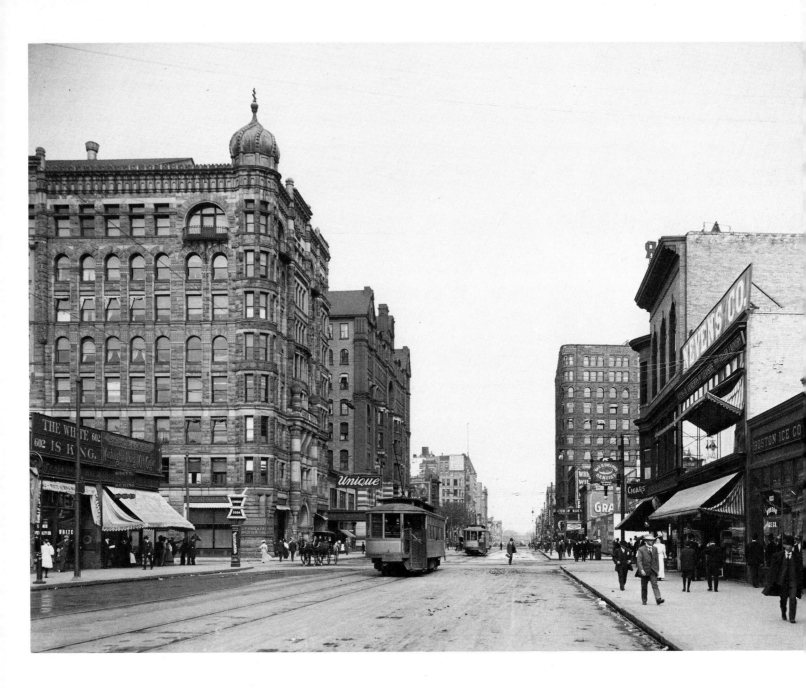

Minneapolis, Minnesota, 1908 Prominent in this photograph is the large structure on the left, the Masonic Temple. The wide avenue passing in front of the Temple is Hennepin Avenue (looking north toward the Mississippi River) and the cross street running south of it is Sixth Street. Just north of the Masonic Temple is the Unique Theatre and the West Hotel, which was destroyed in 1941.

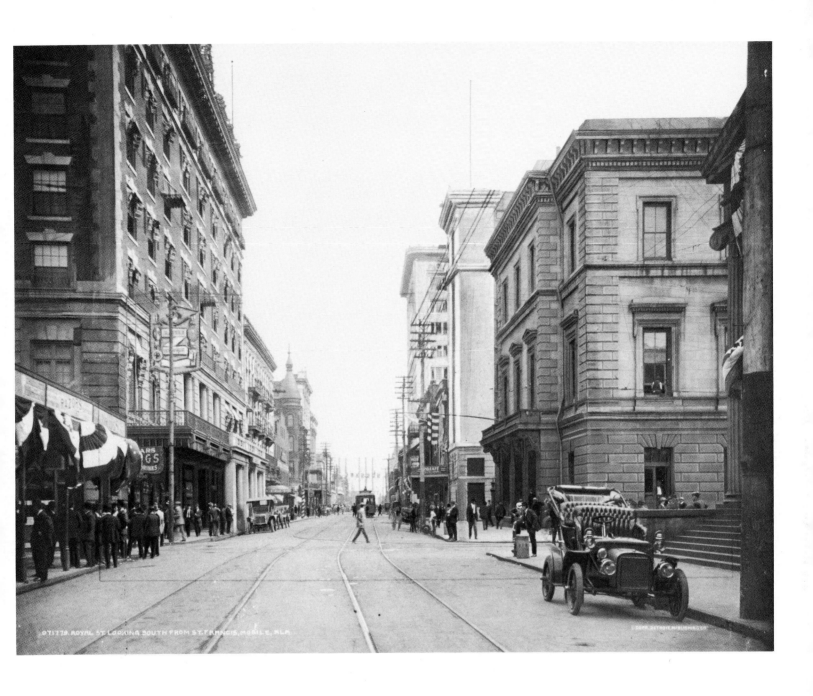

Mobile, Alabama, circa 1910 This is Royal Street looking south. The nearest visible intersection is St. Francis Street. On the southeast corner of that intersection is the renowned Battle House Hotel, which still stands to this day. The massive edifice on the southwest corner of the intersection is the old Customs House–Federal Building, which has since been razed.

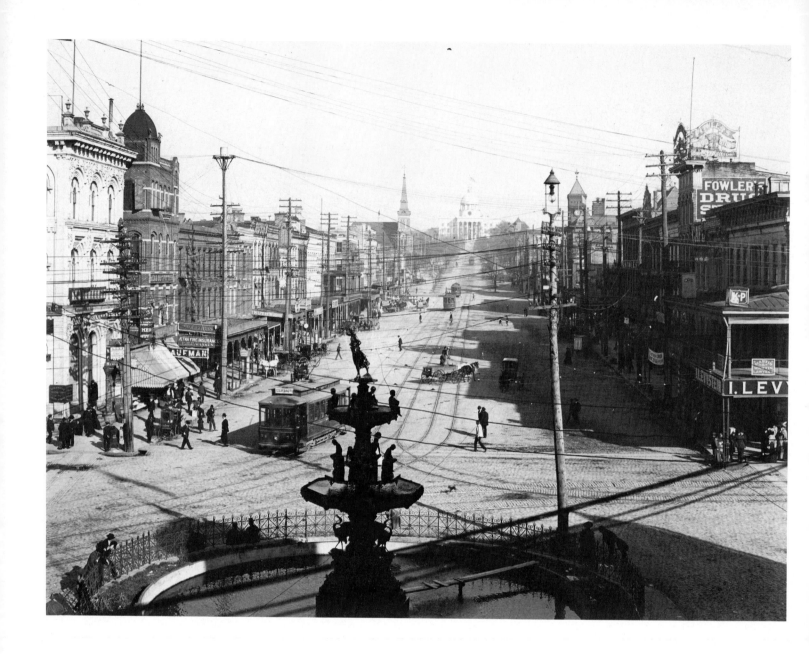

Montgomery, Alabama, circa 1900 The visual center of this photograph is the axis running from the Court Street Fountain to the Alabama State Capitol. Built in 1851, the State Capitol is situated atop Goat Hill at the east end of Dexter Avenue (which runs west to the Court Street Fountain). Constructed of stuccoed brick, this building was the first Confederate Capitol (February to May 1861). In the foreground, the Court Street Fountain marks the intersection of Dexter Avenue with the north–south-running Court Street.

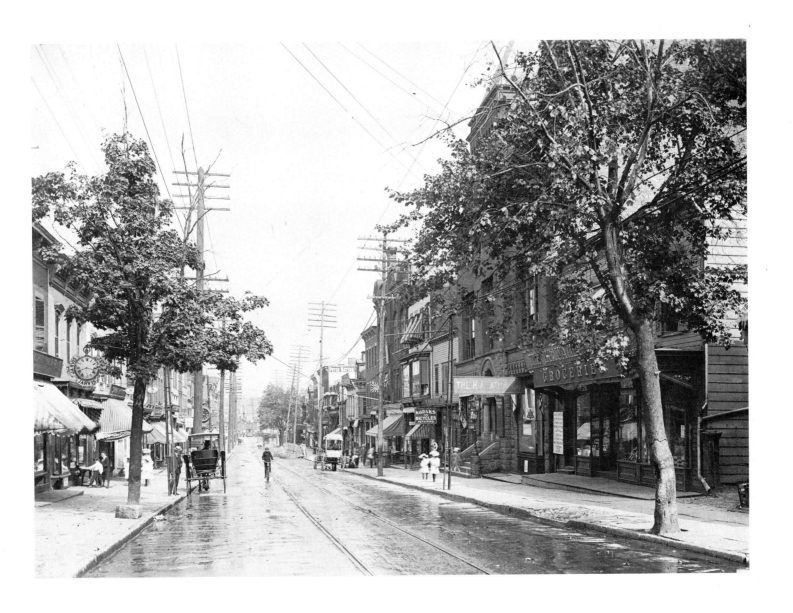

Mount Vernon, New York, circa 1903 This is the paramount downtown thoroughfare of Mount Vernon: South Fourth Avenue (looking north from the intersection with Third Street). On the east side of the street, moving north from the right edge, are: The Hiawatha Co. (groceries); Edward Forsyth (cabinetmaker); the Y.M.C.A.; Conrad Waechter (Kodaks, bicycles). On the west side of the street, moving north from the left edge, are: Mount Vernon Merchants' Delivery & Express; John F. Jarvis & Son (at the clock, watchmakers); Stephen Preston, Jr. (at the eyeglasses, optician).

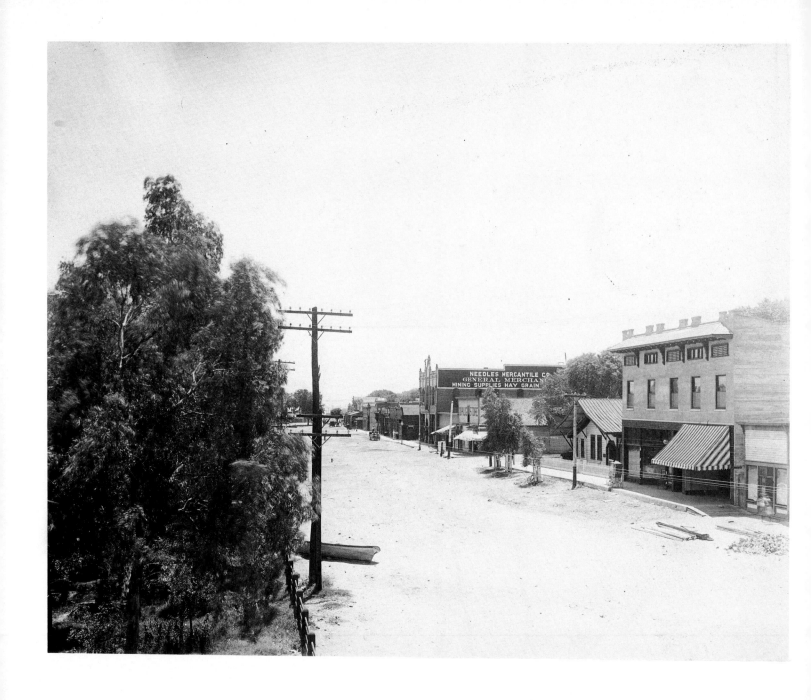

Needles, California, circa 1905 Needles, established in 1883, was a town formed by the arrival of the railroad (the Atlantic & Pacific at the time). Looking down Front Street toward the east, on the left one can make out the fence and shrubbery of the Santa Fe Railway installation. The large building on the right is 815 Front Street, which is still standing, alone among the buildings here depicted, having been for many years an Elks Lodge location, and during that time known as the Elks Building. The structure labeled "Needles Mercantile Co." comprises a portion of what was known as the Briggs Block (burned down in the early 1970's).

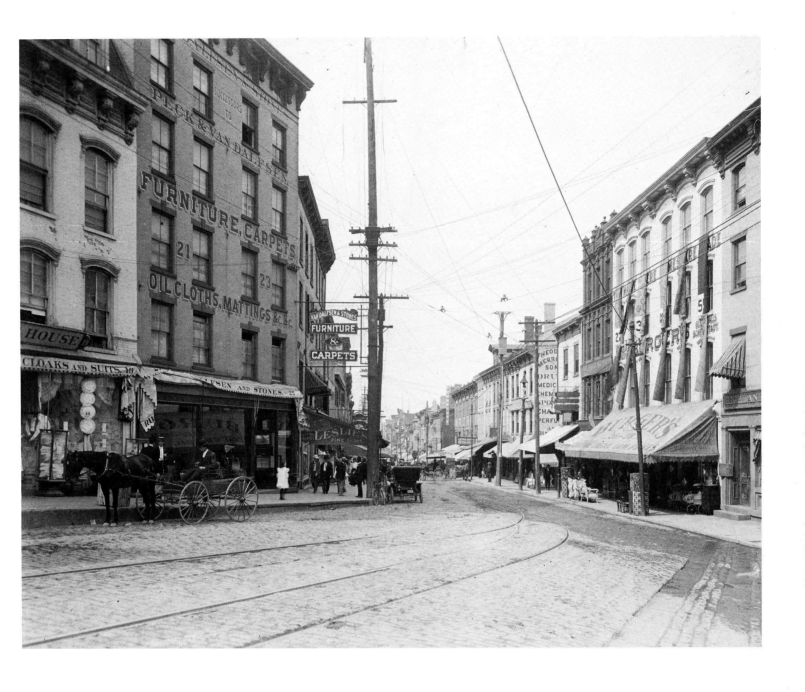

Newburgh, New York, circa 1907 The entire scene shown in this view is now completely gone from this Hudson River city, the victim of urban renewal in the late 1960's. This was once a thriving commercial district in Newburgh, passed over by the course of the twentieth century. Shown here is Water Street, looking north from Clinton Square.

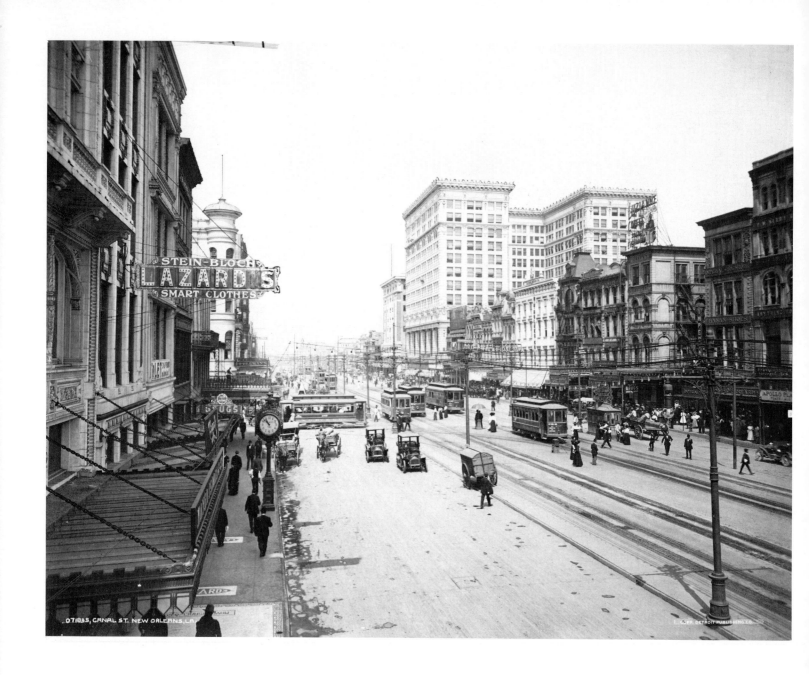

New Orleans, Louisiana, circa 1915 This is Canal Street, the southern boundary of the French Quarter (Vieux Carré), looking north toward the next intersection, on the left, Carondelet Street. The tall building at center is the "new" Maison Blanche–Goudchaux department store (1909), at 901–921 Canal Street. Just north of the Maison Blanche is the Audubon Building (1910) at 931 Canal. At the extreme left of the photo is Lazard's, a clothing store at 718–720 Canal. Between the second and third buildings from the right edge of the picture is Bourbon Street.

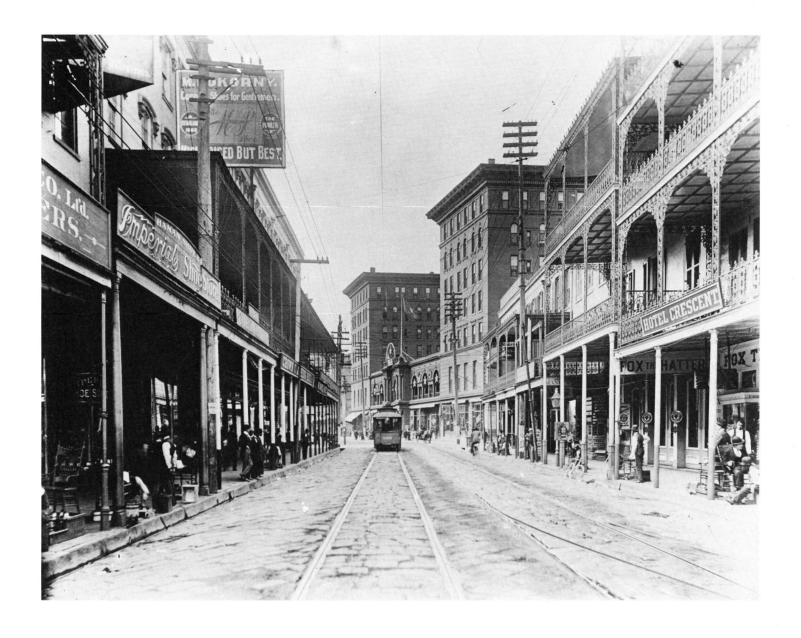

New Orleans, Louisiana, circa 1899 Here is St. Charles Avenue looking west to the massive, two-winged structure of the New St. Charles Hotel, east of which is Common Street. (The hotel, which had just reopened in 1896, was recently replaced by an office building.) At the far right of the picture is the Hotel Crescent (in operation 1893 to 1901). The Imperial Shoe Store (at left) was at this location from about 1894 to 1909, having opened another store on Canal Street in 1902 (see the preceding New Orleans view, just south of Bourbon Street).

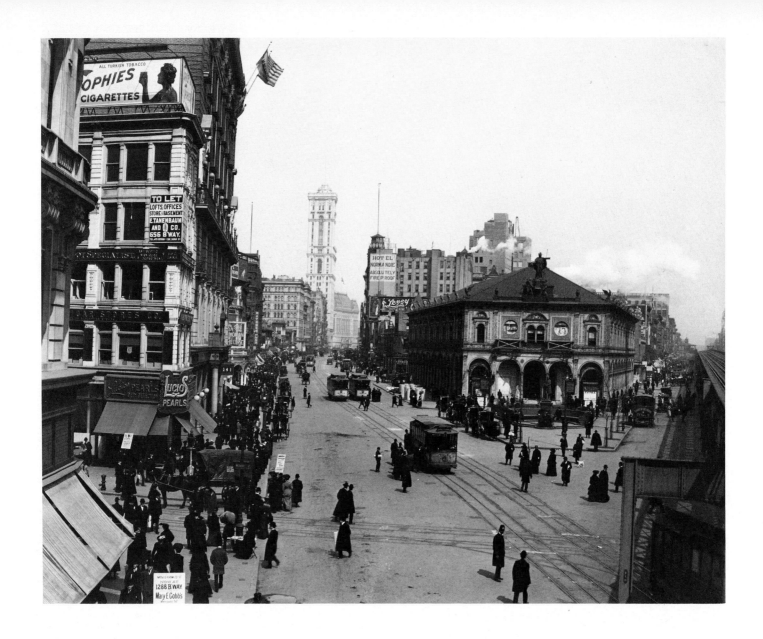

New York, New York, circa 1900 (ABOVE) At the right of this picture we are looking north up the Sixth Avenue "el," and in the left center we are looking north up Broadway to the Times Tower (1903–05, Eidlitz and MacKenzie; stripped and refaced in 1964). Inspired by Giotto's campanile in Florence, the Times Tower was headquarters for the *New York Times* for less than a decade. At the junction of Broadway and Sixth Avenue was the *New York Herald's* newspaper office (1895, McKim, Mead and White); thus the name given to this intersection: Herald Square. The sculptural group on the Herald Building was preserved and remains at this site. The flags at upper left mark Macy's Department Store.

New York, New York, circa 1905 (OPPOSITE) At the center of this view is one of the most historic building sites in the United States, Federal Hall National Memorial (1842). Built in the Greek Revival style, the building occupies the site of Zenger's trial (1735), the Stamp Act Congress (1765), the Continental Congress (1785–88), the inauguration of President Washington (1789) and the first seat of the Federal Government (1788–90). The view is north up Broad Street toward Federal Hall on Wall Street. On the west side of Broad is the New York Stock Exchange (1903, George B. Post) with its sculpture-filled classical pediment, then, as now, one of the financial centers of the world.

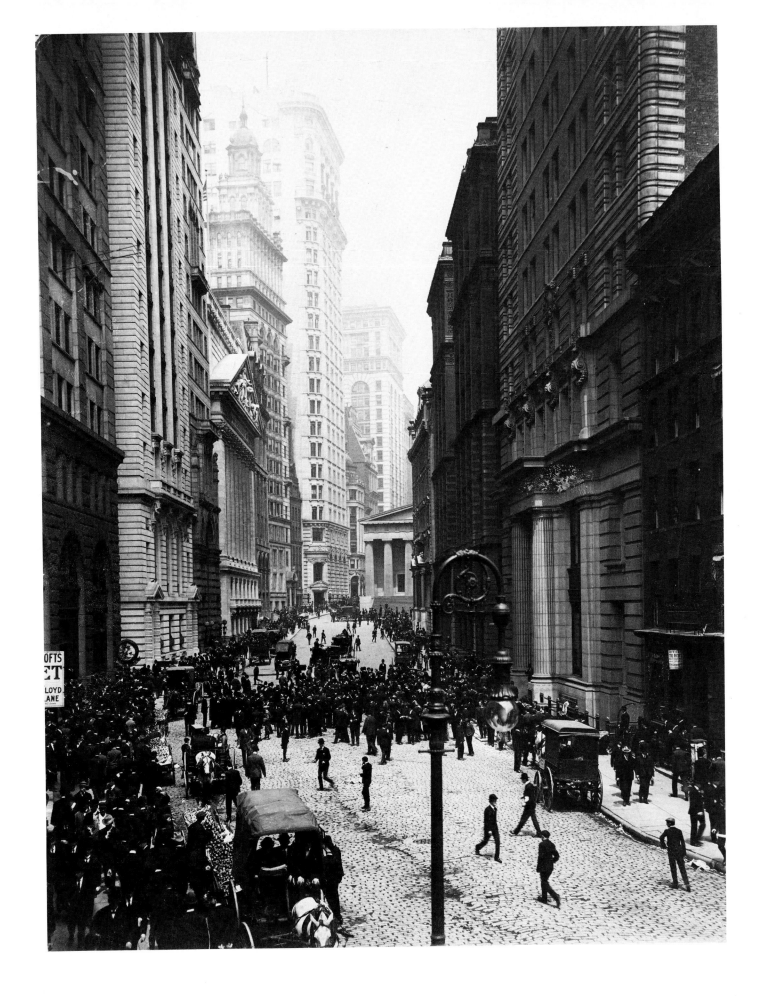

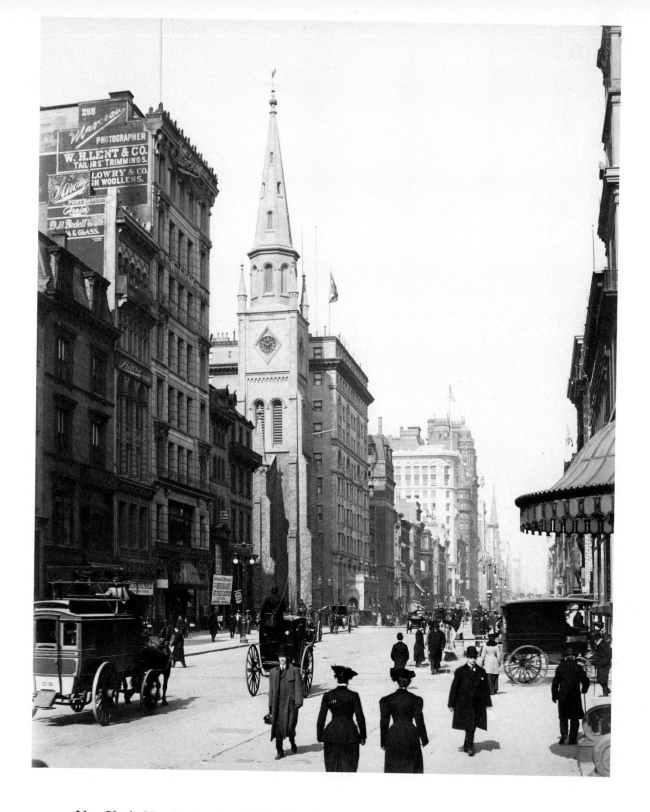

New York, New York, circa 1900 Here is Fifth Avenue looking north from just below the intersection with 28th Street. The church on 29th Street is the Marble Collegiate Church (1854, S. A. Warner), which still stands. Further north (right center) can be seen the old Waldorf-Astoria and the spire of the Brick Presbyterian Church (1858) on the northwest corner of West 37th Street. The awning at extreme right belongs to The Knickerbocker, New York's first cooperative apartment building (1883).

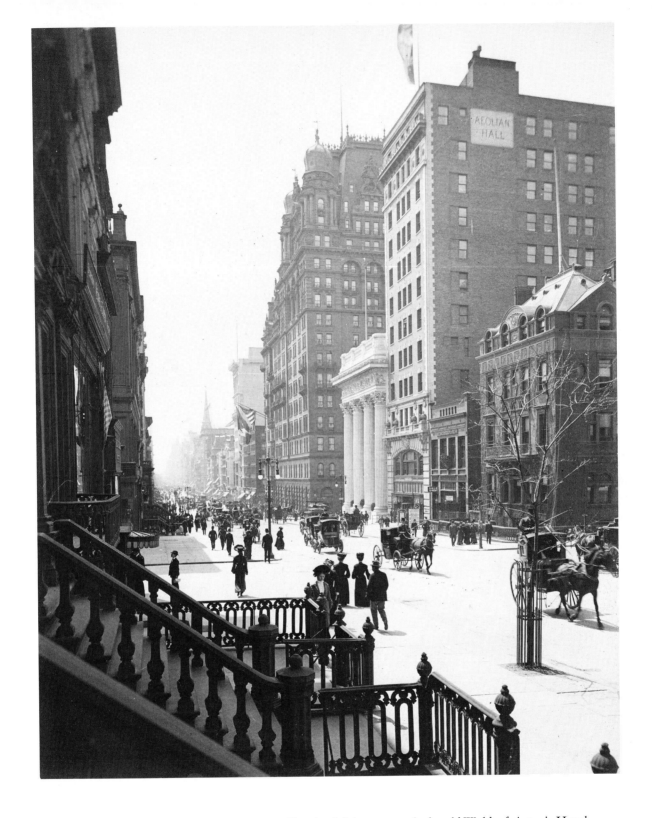

New York, New York, circa 1900 Clearly visible at center is the old Waldorf-Astoria Hotel (1897, Henry Janeway Hardenbergh), with its conspicuous corner turrets, standing at the corner of Fifth Avenue (here shown looking south) and 34th Street. (Hardenbergh also designed two landmarks still standing in the city, the Dakota Apartments and the Plaza Hotel.) The Astor mansion, focal point of New York society in its time, had previously occupied the site of the Waldorf. In 1930, the Waldorf-Astoria was torn down and in its place was built the Empire State Building.

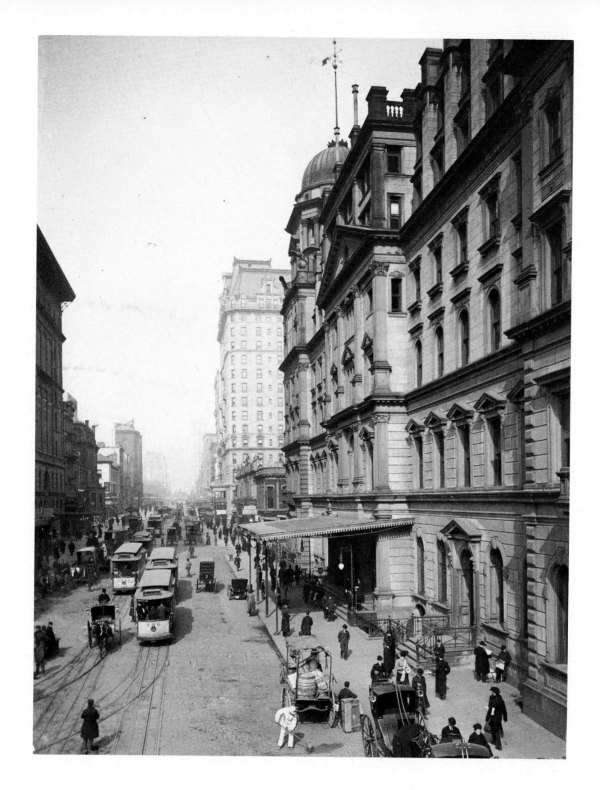

New York, New York, circa 1903 At the right of this photograph is the baroque mass of Grand Central Terminal. The terminal had been extensively remodeled in 1898 by Bradford L. Gilbert. In 1913, however, the entire structure was replaced by the terminal that now stands on the same site. 42nd Street here presents a vista stretching off into the west. The structure that seems to be blocking 42nd Street in the distance is on Fifth Avenue. The bottom edge of the photograph is located between present-day Park and Vanderbilt Avenues.

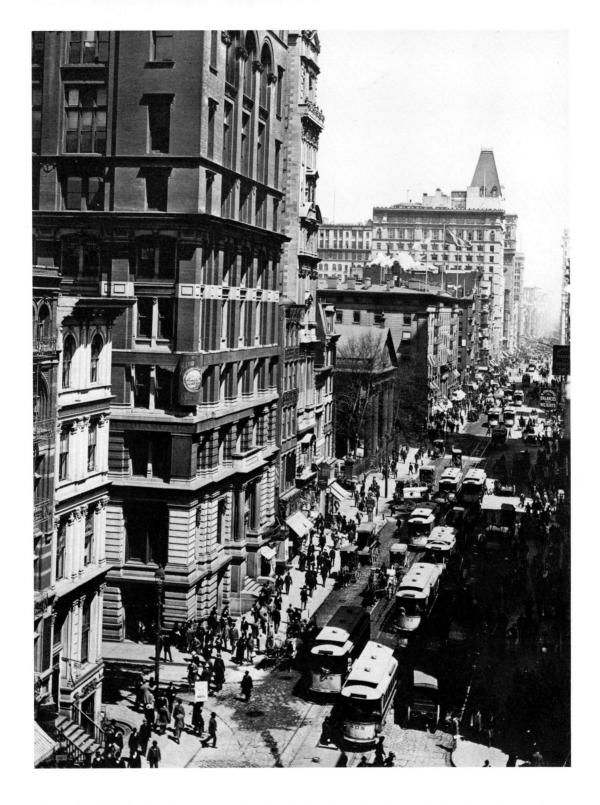

New York, New York, circa 1900 Here is Broadway looking north from Dey Street (the nearest street on the left). In the center of all this commercial bustle can be seen the Ionic columns of New York City's only remaining Colonial church, St. Paul's Chapel (1766, Thomas McBean; tower and portico added 1794 by James C. Lawrence), bounded by Fulton Street on the south and Vesey Street on the north. Just north of St. Paul's is seen the Astor House (1836, Isaiah Rogers), New York's first first-rate hotel, and the city's first with lavatory facilities on every floor. The Astor House was demolished in 1926, the favored locations for luxury hotels having moved uptown some fifty years earlier.

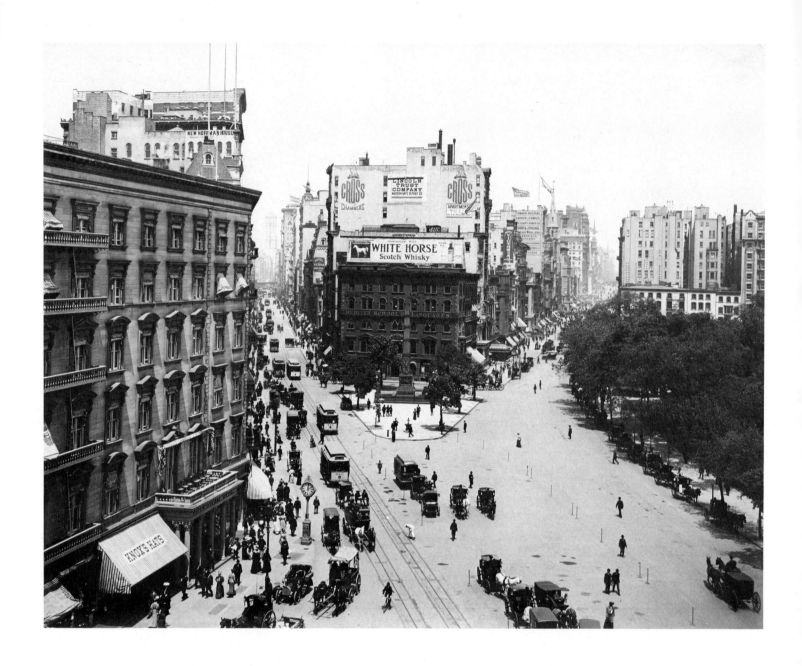

New York, New York, circa 1905 This is Madison Square, the confluence of two great New York thoroughfares, Broadway (looking north to the left, and following the tracks of the trolleys) and Fifth Avenue (to the right). On the right is Madison Square Park. The photograph was probably taken from the 1902 Flatiron Building on 23rd Street. The grand entrance to the Fifth Avenue Hotel, at one time New York's most prestigious, is visible at left. The obelisk (center) is both monument and place of burial for Gen. William J. Worth, Mexican War hero (1794–1849).

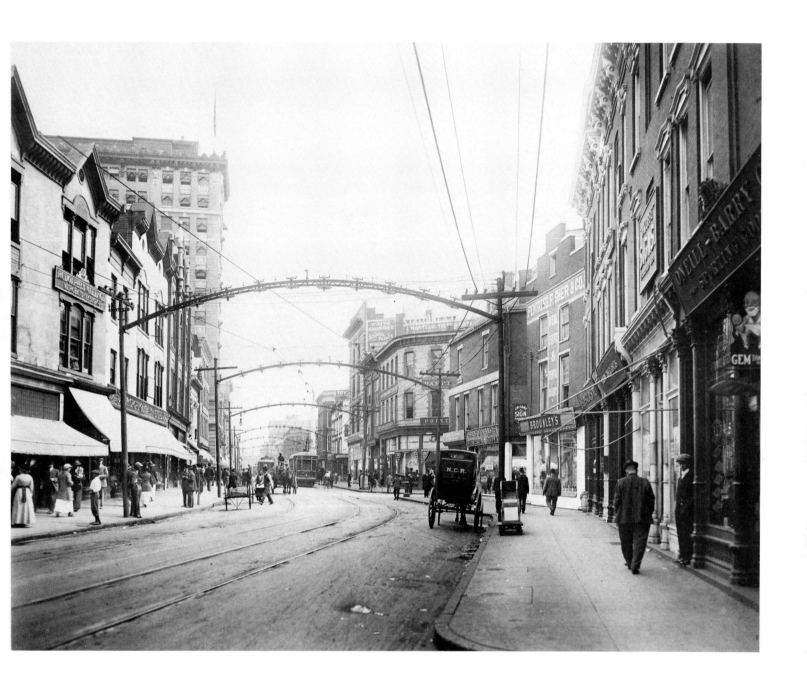

Norfolk, Virginia, circa 1913 This was the commercial heart of Norfolk. The camera was placed at the corner of Holt Street, looking down E. Main Street to Commerce Street. At extreme left is the Academy of Music Building, in which a number of different businesses were located. The tall building at left is The National Bank of Commerce. In the distance (left center) is the Victoria Hotel. The curved structure at center is the Hampton Roads Paper Company.

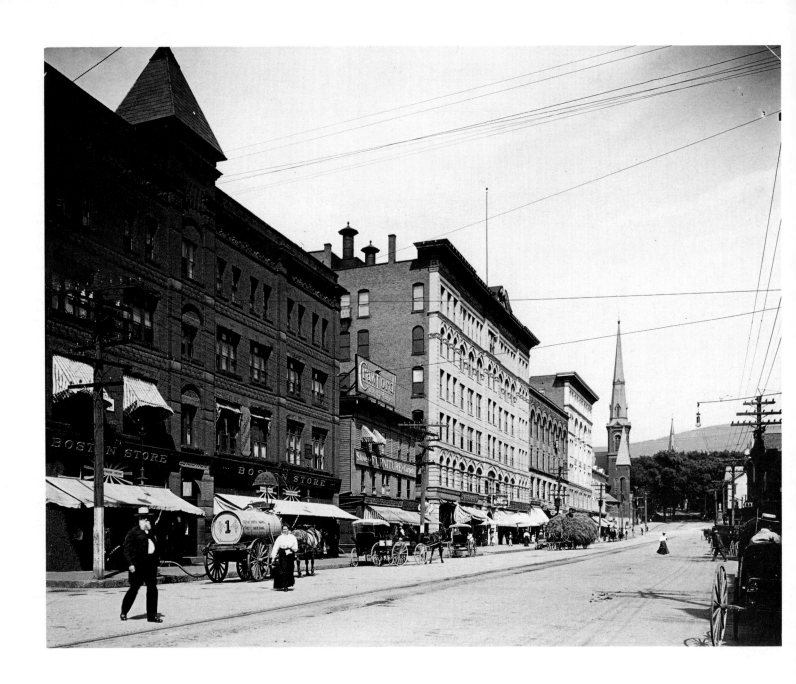

North Adams, Massachusetts, circa 1900 This is the mercantile downtown of North Adams, an industrial city in the Berkshire Mountains. The view is looking east down Main Street toward Church Street. The prominent steeple on Main Street is part of the Baptist Church.

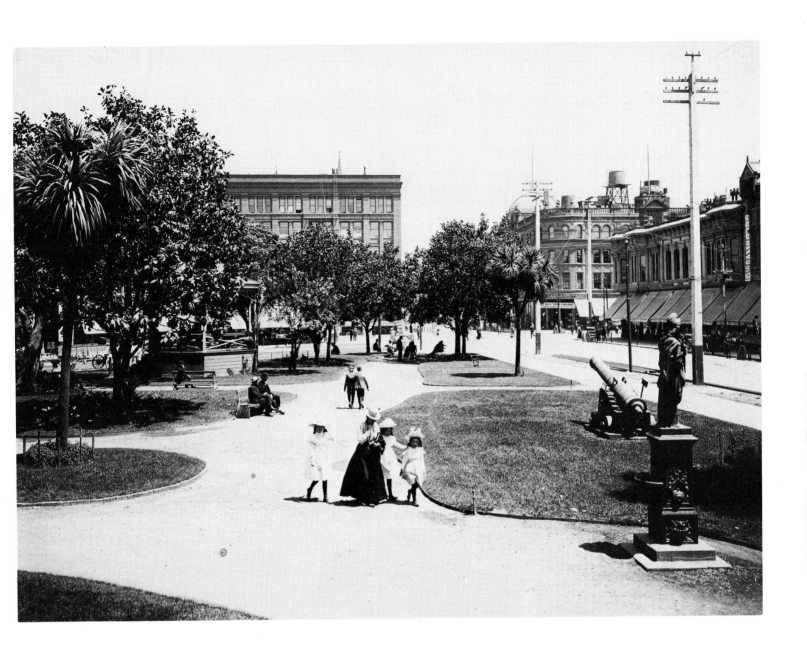

Oakland, California, circa 1900 This is Oakland's City Hall Park. The City Hall was located on 14th Street (the street at right, looking east in the direction of Broadway, the eastern limit of the park at this point). This structure lasted from 1877 to 1913, when it was superseded in the same location by the present City Hall. Diagonally across from the park is the MacDonough Theater building (1892–1956), the city's first sizable theater.

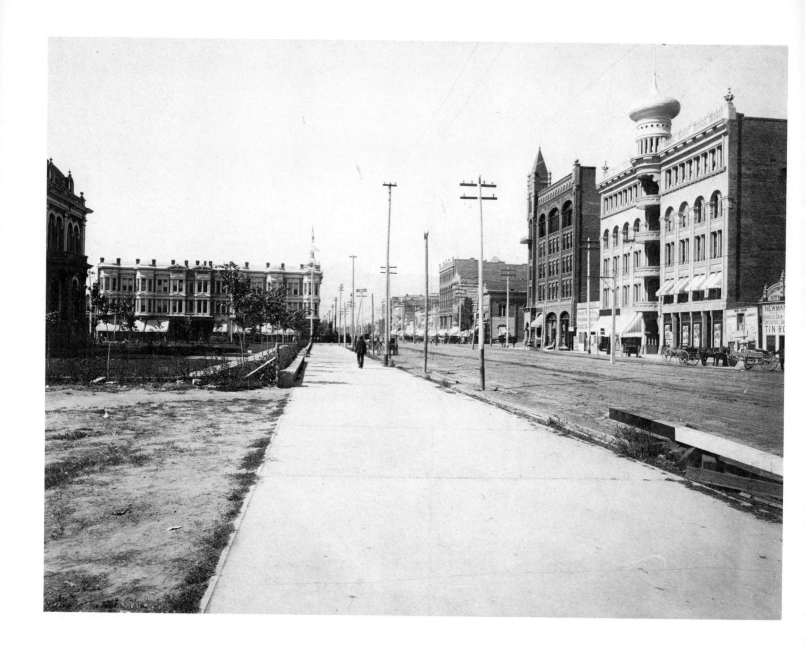

Ogden, Utah, circa 1902 Here is a vista including a number of important Ogden landmarks, photographed shortly after the turn of the century. At extreme left is a portion of the Ogden City Hall. The three-story structure to the right of City Hall is the Broom Hotel. The building near the right edge of the picture with the onion-shaped cupola is the Orpheum Theater. The five-story building to the left of the Orpheum is the Reed Hotel. The road seen here is Washington Boulevard looking north toward 25th Street.

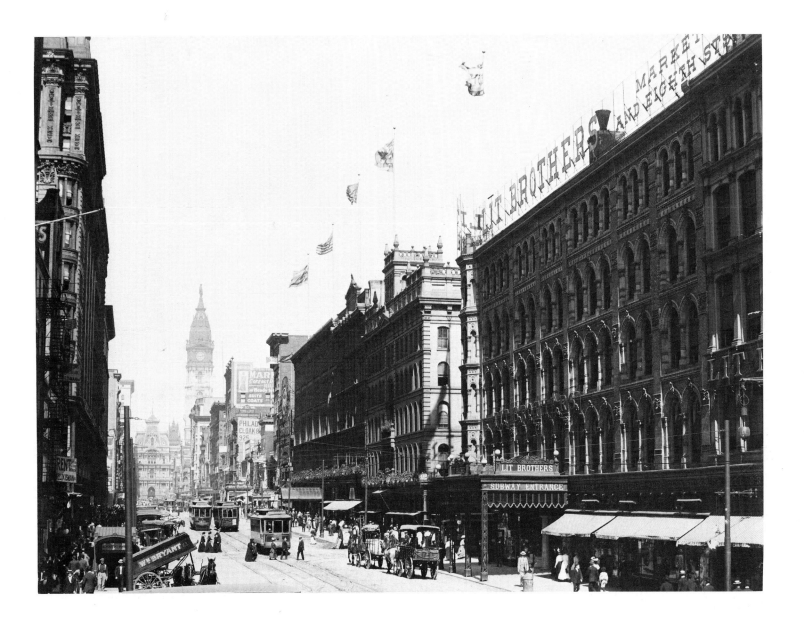

Philadelphia, Pennsylvania, circa 1908 Here is a section of downtown Philadelphia characterized by large mercantile establishments. The street is Market Street (from the vantage of 7th Street) looking west toward City Hall with its 548-foot tower surmounted by a statue of William Penn, until recently by law the tallest structure in Philadelphia. At far right is Lit Brothers Department Store (Collins and Autenrieth), which is still standing with its remarkable façade of cast iron. In late 1987, after extensive and expensive renovations, Lit's became the Mellon Independence Center, with both office space and street-level shops. To the west across 8th Street is the Strawbridge & Clothier Department Store, which has since been considerably altered in appearance.

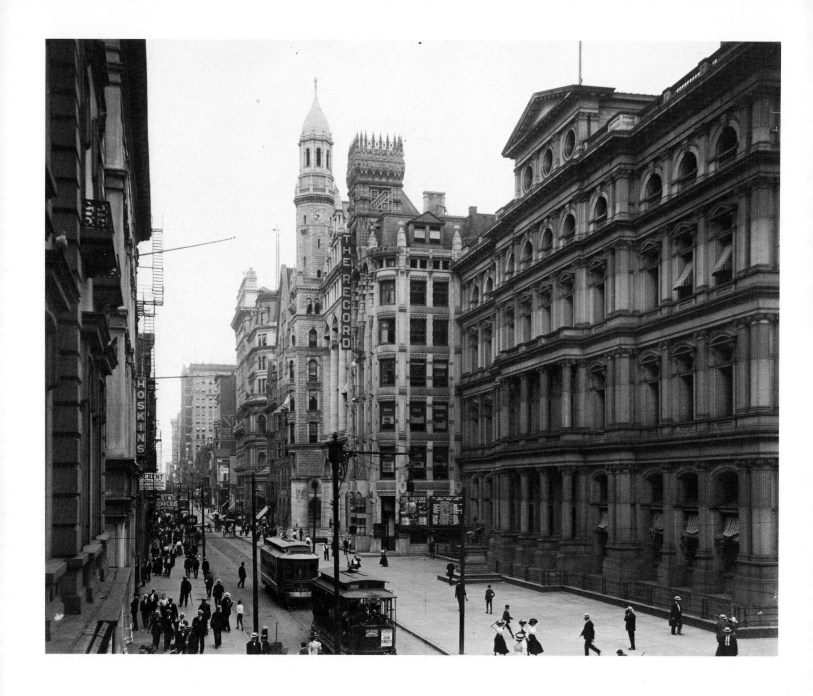

Philadelphia, Pennsylvania, circa 1905 Certain Philadelphia architects in the nineteenth century (e.g., Frank Furness) gave much of that city's architecture a rich complexity, even eccentricity. Although many important buildings have been destroyed in the interim, their continuing influence can be traced in the postmodern movement in architecture. Good examples of this asymmetrical mutation of the High Victorian are the Philadelphia Record Building (1881) and (to its left) the Penn Mutual Life Insurance Co. Building. At extreme right is the U.S. Post Office (1873–1884, Alfred B. Mullett), replaced in 1935 by the present Post Office. The street here is Chestnut Street looking west from 9th Street to 10th Street and beyond.

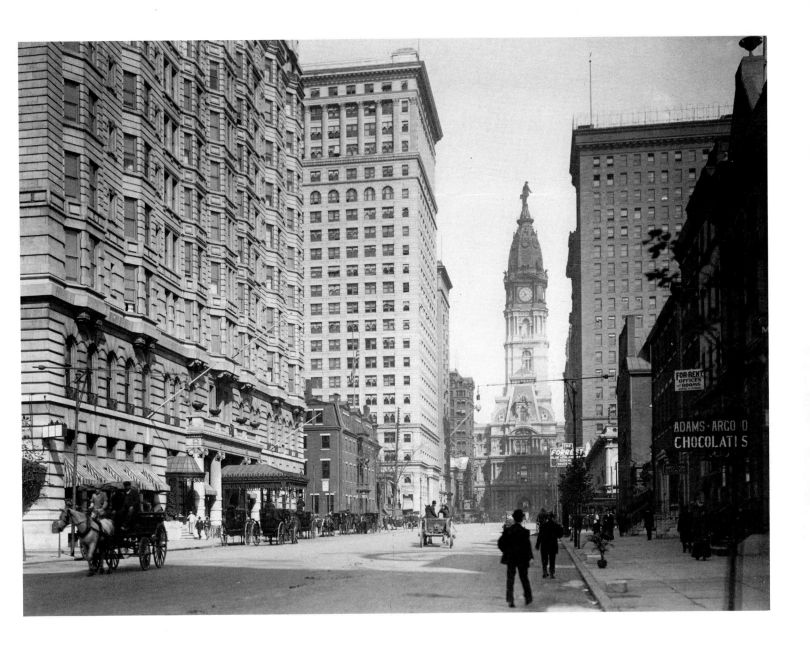

Philadelphia, Pennsylvania, circa 1908 Here is a distinguished pocket of Philadelphia south of City Hall. On the left is the Bellevue-Stratford Hotel, which opened its doors for the first time in 1904. Just to the north, along Broad Street, is the Old Bellevue Hotel, which closed in 1904. Continuing north is the relatively diminutive Union League building and, across Walnut Street, the towering Land Title and Trust Building. The tall building on the east side of Broad Street is the North American Building.

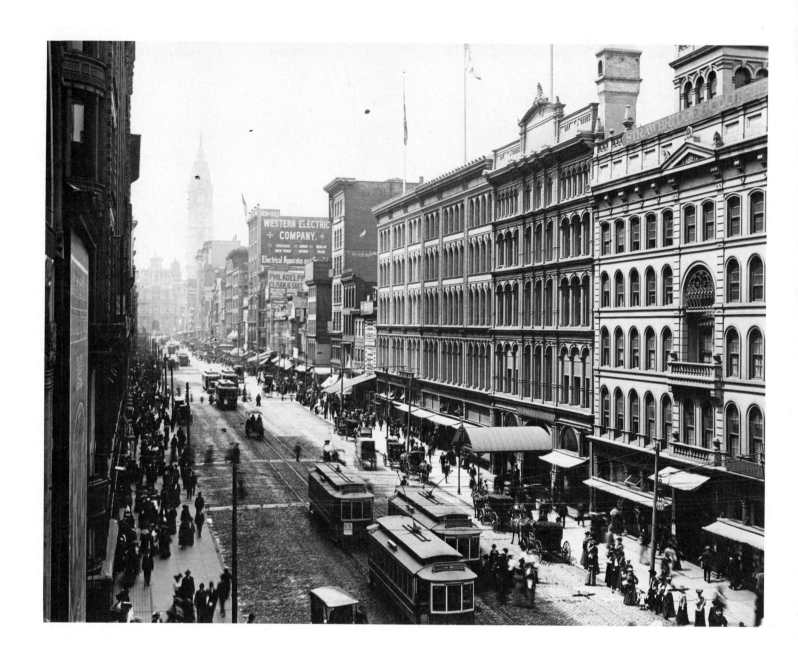

Philadelphia, Pennsylvania, circa 1908 Here is another view of Market Street. At extreme left is the Gimbel Brothers Department Store. Philadelphia is not generally known for its large department stores, though it has had some notable ones (e.g., the palatial Wanamaker's). The area depicted here had three sizable ones, Gimbel Brothers, Lit Brothers and Strawbridge & Clothier. Initiated in 1868, Strawbridge & Clothier was the first of this trio of mercantile establishments and was followed by Lit Brothers and, finally, by Gimbel Brothers. Further west on Market Street (somewhat to the right of City Hall in the photo) is the Blum Brothers building, another Philadelphia department store, though not as big as those mentioned above.

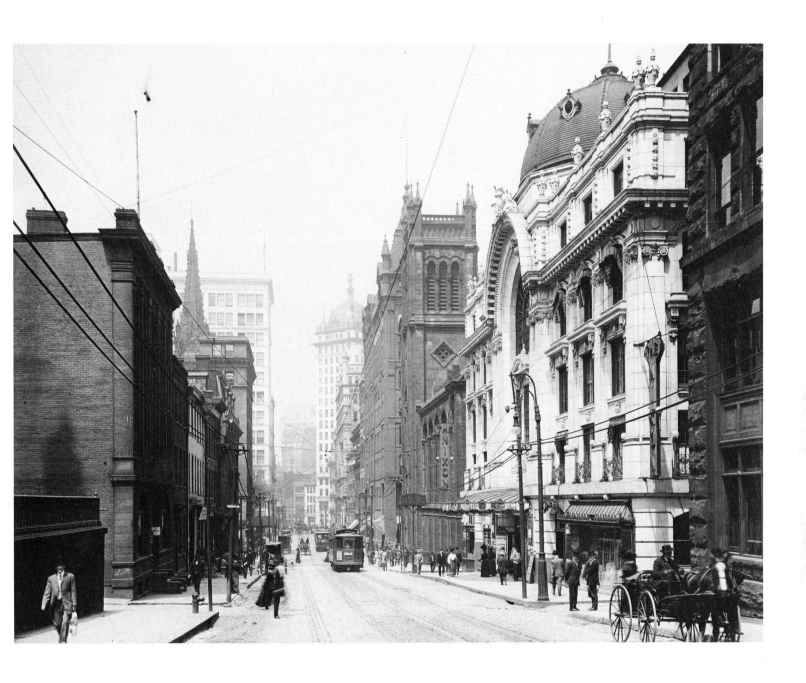

Pittsburgh, Pennsylvania, circa 1910 This is downtown Pittsburgh after the turn of the century. The magnificent white structure at right is the Nixon Theatre. In this view, which faces northwest on Sixth Street, the building to the left of the Nixon is the German United Evangelical Protestant Church, to the right of which, across Smithfield Street, is the Lewis Block. The tall, domed building in the center of the photo is the Keenan Building. On the left is visible the stone spire of Trinity Episcopal Cathedral, behind which is a large, white edifice, the McCreery Building.

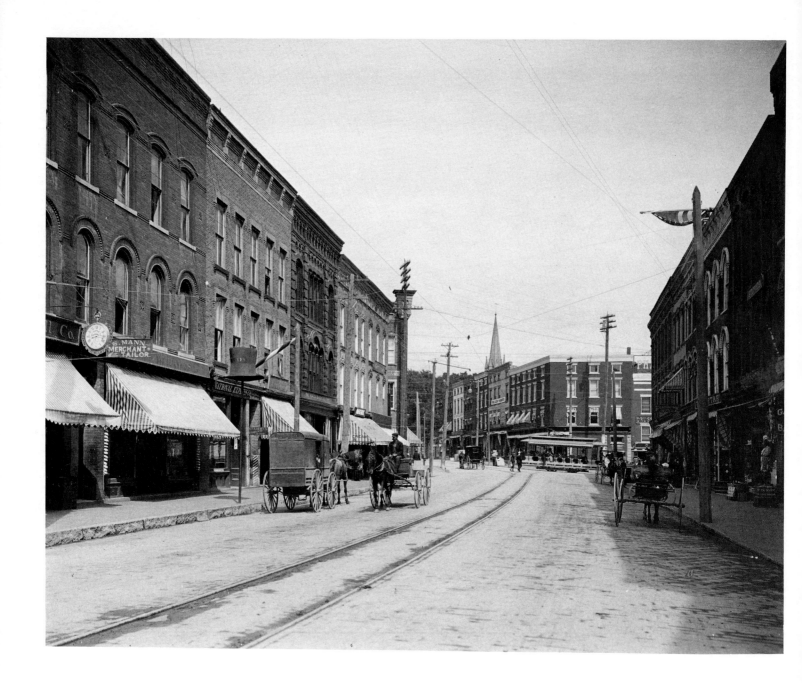

Plattsburgh, New York, circa 1903 At the time this photograph was taken, this was the main commercial thoroughfare in Plattsburgh. Although that is no longer the case, most of the structures depicted here still remain in place. Shown is Margaret Street (the camera facing north). The next intersection (to the north) is with Bridge Street.

Plymouth, New Hampshire, circa 1905 This is the heart of Plymouth, centering on the common. In the center of the picture is a watering trough, to the left of which, within the common, amid the trees, is the Bulfinch Bandstand (built 1903). The photo was taken from the middle of Main Street and looks south to the common, which divides Main Street in two. On the right Main Street joins with Highland Street, which goes off to the southwest and then veers west. On the left Main Street passes by the common going south and is considered part of Route 3.

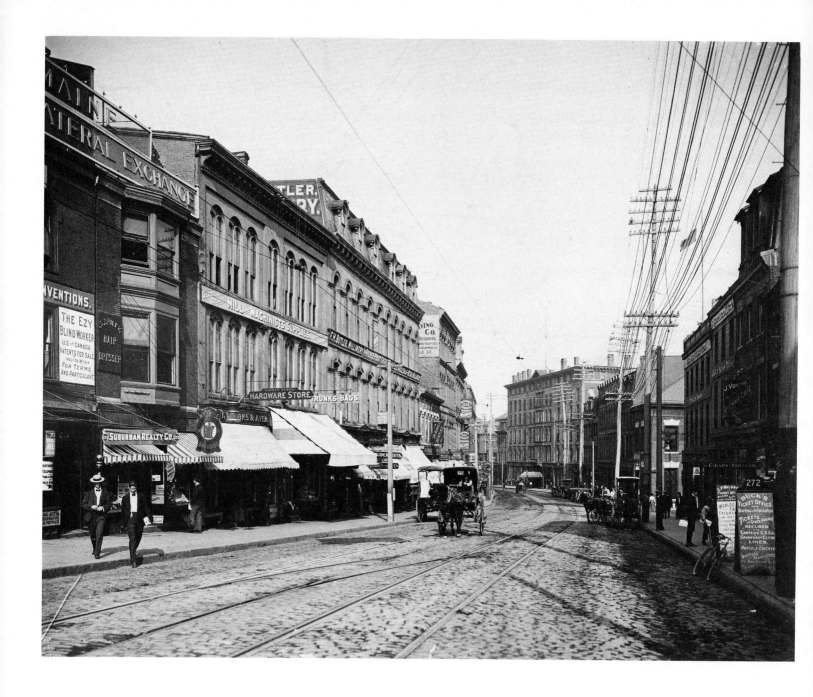

Portland, Maine, circa 1890 In the middle of downtown Portland, here we have Middle Street (looking down from Congress Street). The buildings on the right side of Middle Street in this view are still extant (for the most part). The structures on the left side of Middle Street have been replaced by a modern office building. These structures had all been built following a disastrous fire which burnt down much of Middle Street on July 4, 1866.

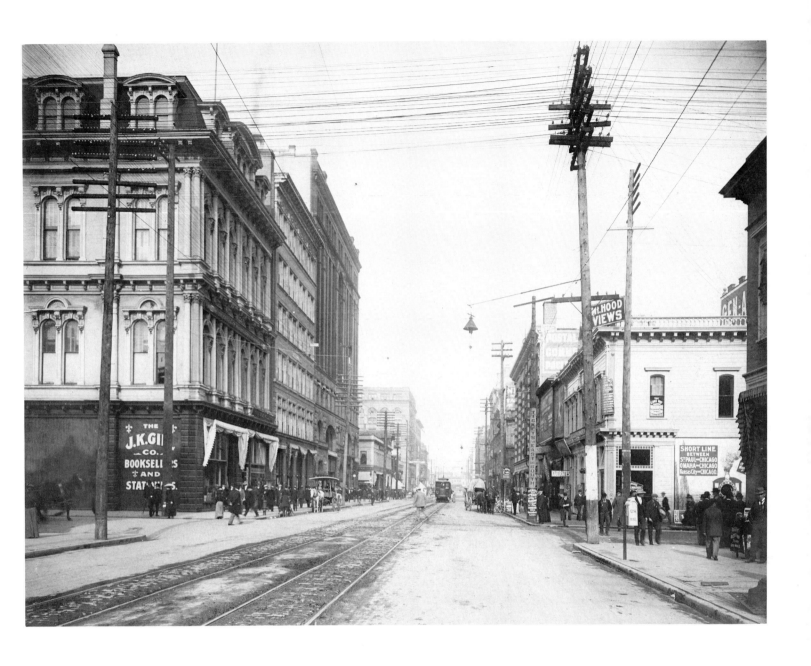

Portland, Oregon, circa 1900 This photograph by S. G. Skidmore shows downtown Portland at the turn of the century. This is S.W. 3rd Street, looking south toward Washington Street, on which is located the Dekum Building, built in the 1890's.

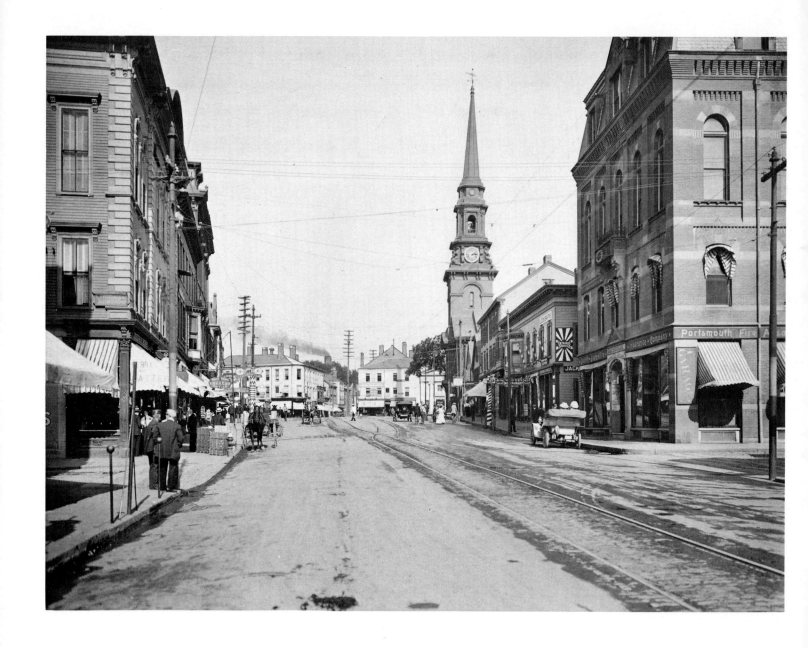

Portsmouth, New Hampshire, circa 1905 This is the center of Portsmouth. Here we are looking to the northeast down Congress Street. The next intersection is with Fleet Street (foreground). At extreme left is the Mechanics & Traders National Bank Building. At extreme right is the National Block (1878). The prominent church near the center of the photo is the North (Congregational) Church, built in 1854, replacing the old meetinghouse, which dated from 1712. To the left of and slightly beyond the North Church in this photo is Market Square (also known as the "Parade").

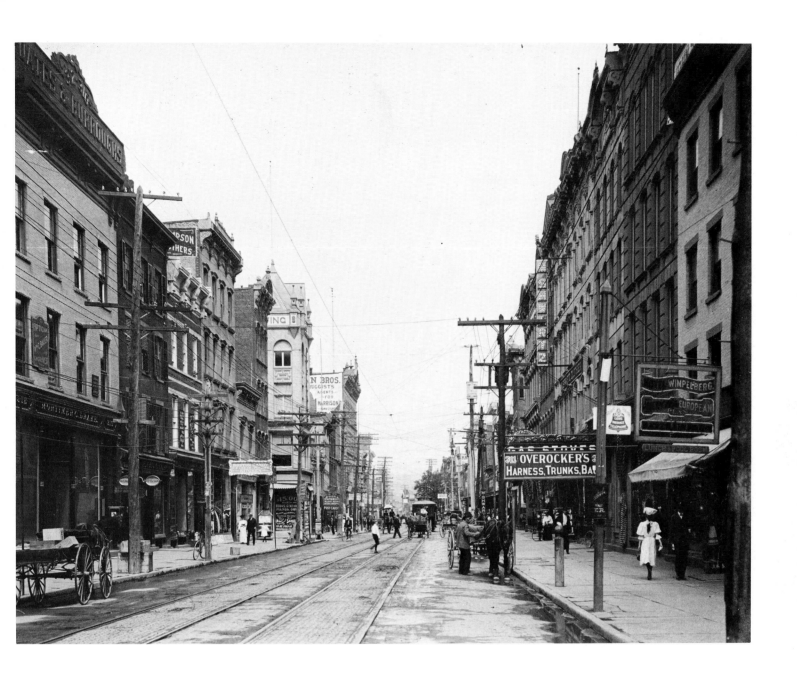

Poughkeepsie, New York, circa 1912 This is Main Street looking west toward Market Street. Liberty Street is to be found, on the left, just east of the tall white building that advertises pianos in a ground-floor window.

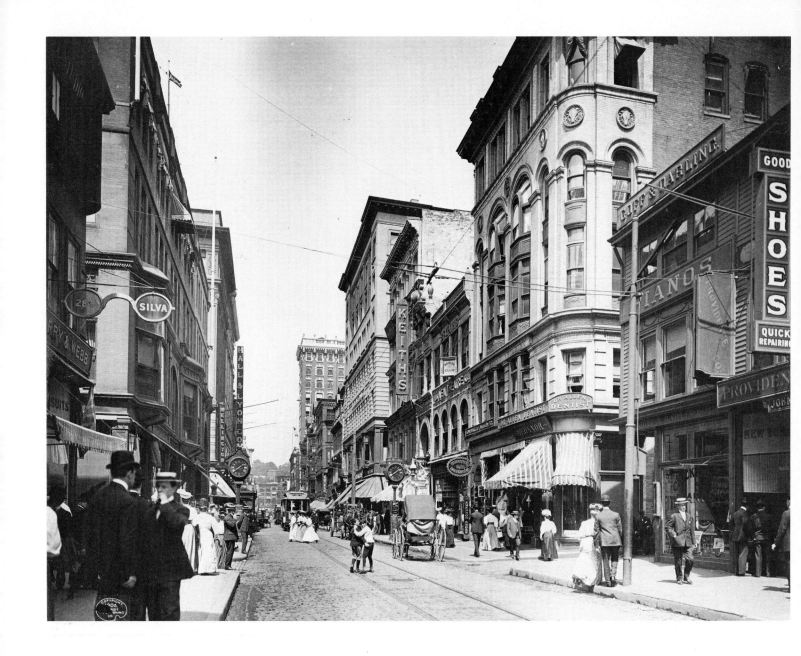

Providence, Rhode Island, circa 1905 This is one of the central axes of downtown Providence, Westminster Street (looking toward the east). At the center is Keith's Theatre, a key establishment in Benjamin Franklin Keith's vaudeville empire. Keith revolutionized vaudeville in the late nineteenth century by emphasizing "refinement" and "respectability," a move that proved successful and profitable. At left center (just above the trolley) is the balustrade-surmounted Union Trust Building (1901, Stone, Carpenter and Willson), a 12-story Beaux-Arts masterpiece. Directly left of Union Trust's parapet is the cornice of the Shepard Company Building, at the time of the photo New England's biggest department store. Much of Westminster Street (including the area pictured here) has been a pedestrian mall since 1964.

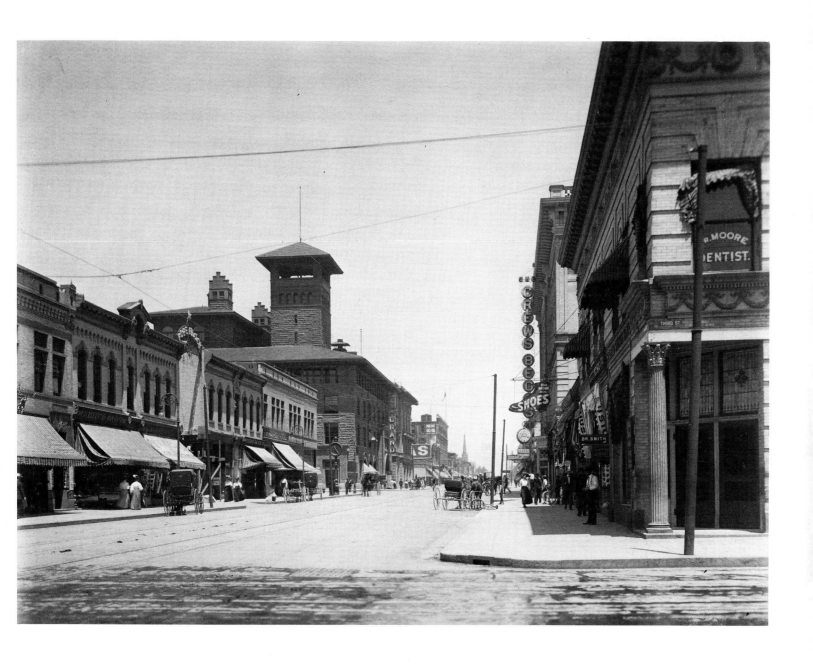

Pueblo, Colorado, circa 1905 Here is the very center of Pueblo's downtown area. Dominating this view is the Grand Opera House (1890, Louis Sullivan; burned down 1922), on Fourth and Main Streets; note the sign "Grand" hanging in front. The Grand housed businesses (banks, etc.), as well as a 1,100-person-capacity theater (in the heart of the building), and was constructed of Manitou red rock and granite. To the left, the Pope Block is visible, with the arc of its sign. At extreme right is the Guggenheim Building (1899; destroyed 1982), built by the well-known Guggenheims of Philadelphia who owned local smelting plants. In the distance (looking east down Main Street) is the First Presbyterian Church (1890).

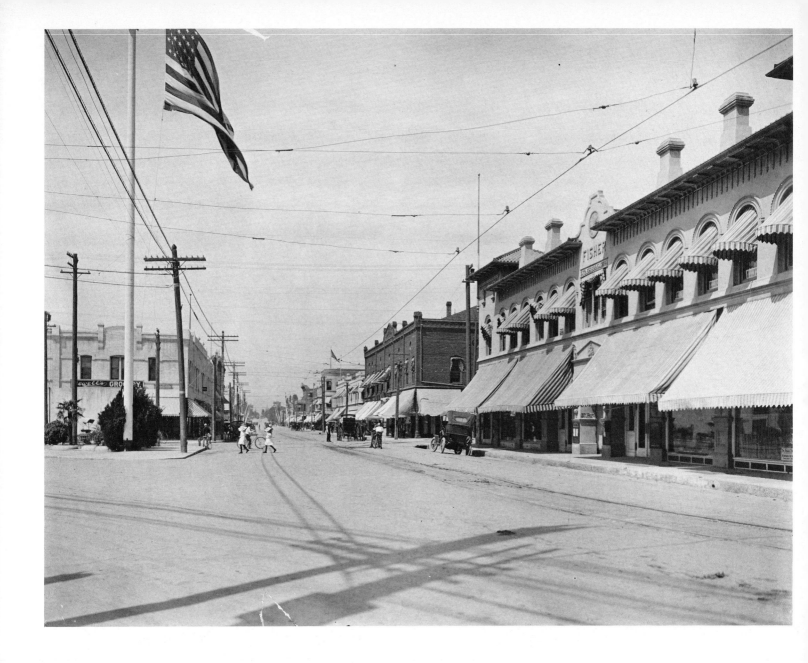

Redlands, California, circa 1905 (ABOVE) Here is Orange Street, looking north. The next intersection to the north is that with Citrus Avenue. At extreme right is the Fisher Building (1899; no longer standing). To the north of the Fisher Building is the Academy of Music Building (1895; still standing). The large flagpole at left has since been supplanted by a walnut tree. In the hazy distance to the north are the San Bernardino Mountains.

Richmond, Virginia, circa 1900 (OPPOSITE) This photo shows a historic section of downtown Richmond, characterized, in part, by cast-iron-fronted commercial buildings. The street is Main Street (looking west); the complete block seen on the south side of the street is the 1000 block. At 1017–19 is O. H. Berry & Co. (clothing). Just to the west is the Branch Building (c. 1866) at 1015 E. Main Street, an example of the High Victorian Italianate style. Next door at 1007–13 is the Stearns Iron-Front Building (c. 1865–69), like the others a brick structure with a cast-iron front. The Stearns Building is an example of the Italian Renaissance Revival style.

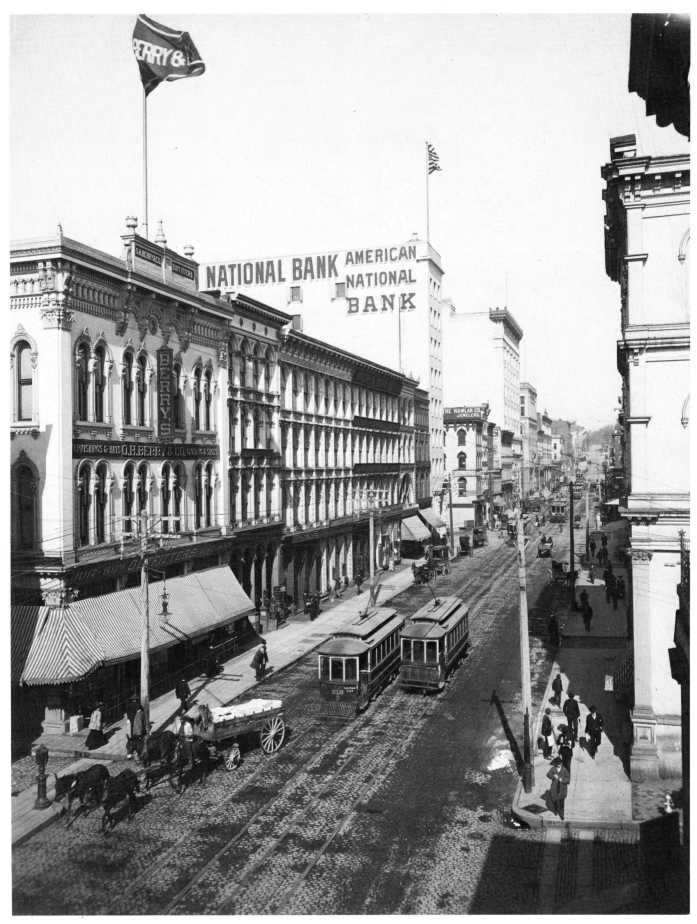

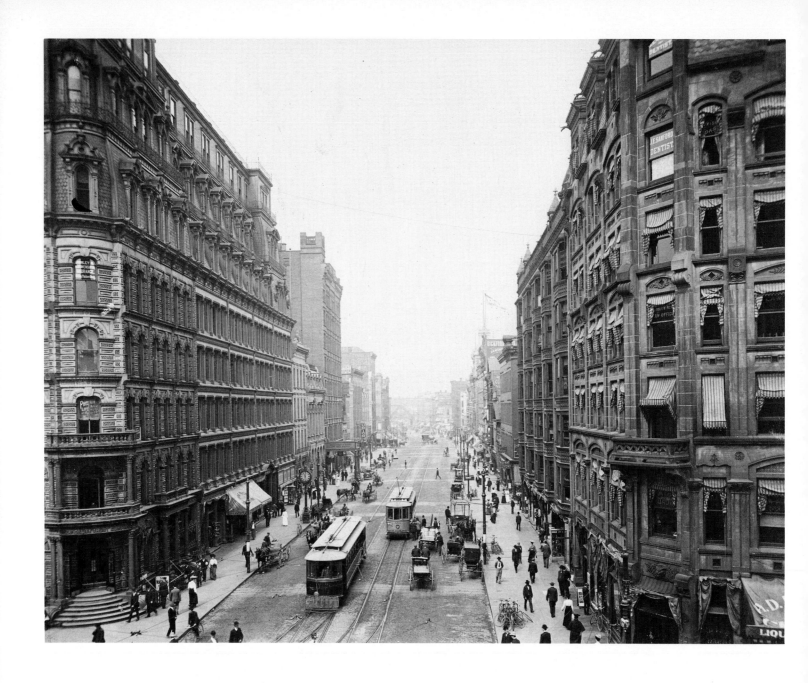

Rochester, New York, circa 1900 This is the heart of Rochester's business district. This particular view is of State Street, which begins at the intersection with Main Street (from which the photo was taken) and continues north. The large structure on the left is the Powers Building (1869, Andrew J. Warner); with its metal-frame construction, it was Rochester's first fireproof building. The first floor was significantly altered in the twentieth century but is currently being restored. The building on the right is the F. W. Elwood Building (no longer extant).

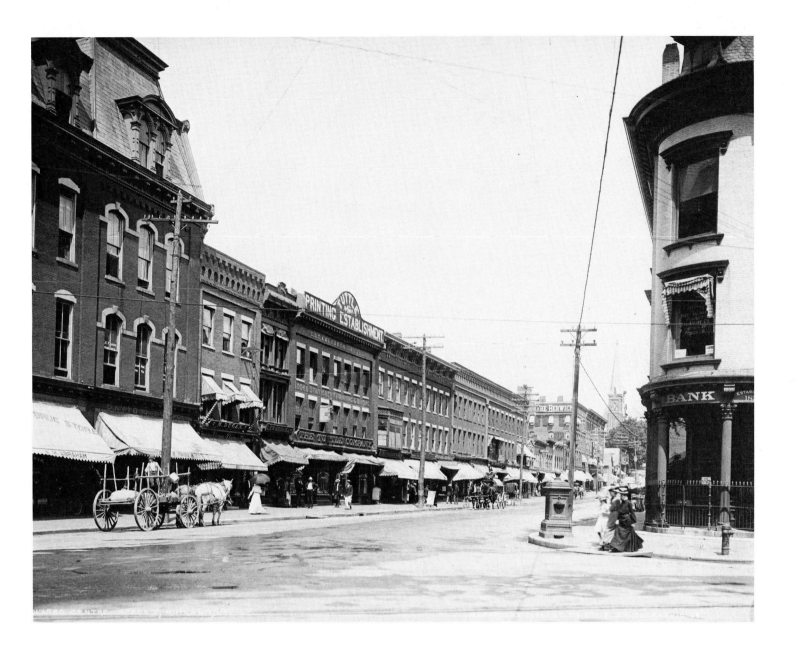

Rutland, Vermont, 1904 The row of establishments along the northern side of Center Street is as follows from the left edge of the photo: A. H. Abraham, drugstore; David B. Twigg & Co., clothing store; Michael Dugan, wine and spirits; Lew Abraham, cigar maker; Tuttle Company, printing house; Fred Fenn, restaurant and vintner; Frank M. Grow, musical items; John H. Dugan, alcoholic beverages; and, following some indiscernible storefronts, the Berwick Hotel. The church spires belong to the Congregational Church (left) and the Baptist Church (right). At extreme right is the Rutland Savings Bank building.

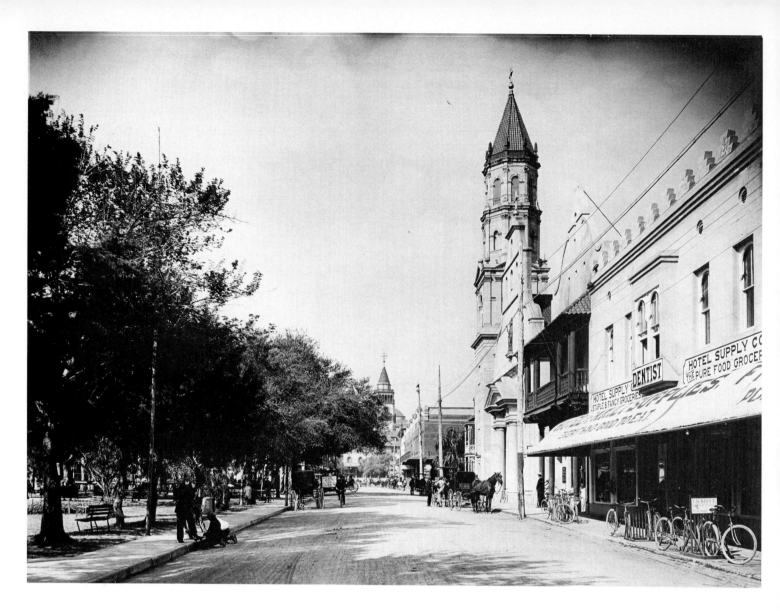

St. Augustine, Florida, circa 1907 (ABOVE) It should not be surprising that in America's oldest city is to be found America's oldest parish (1594), the Cathedral of St. Augustine (right center). The building shown here was originally built in 1797, fire-gutted in 1887 and restored, adding the tower, by the end of the next year by James Renwick. To the west of the Cathedral (the photo as a whole is looking west down Cathedral Place) is St. George Street, across which is the Bishop Block. From the right edge of the photo, moving left, one finds the Vaill Block (housing the Hotel Supply Company) and the First National Bank. The tower in the background, marking the terminus of Cathedral Place as it is crossed by Cordova Street, is a section of the Hotel Ponce de Leon (1888), now Flagler College (1967).

St. Louis, Missouri, circa 1894 (OPPOSITE) Favored by proximity to natural resources and a strategic location along the Mississippi (and in the center of the United States), St. Louis was an important trade and manufacturing center. Here, in the commercial heart of St. Louis, is Olive Street (looking west toward 7th Street). Two large buildings here reflect the city's growing importance and prosperity. The 705 (Olive Street) Building (1893, Adler and Sullivan, with Charles K. Ramsey), topped by a metal "cage" and with a heavy cornice and classical elements, was St. Louis' tallest (at 14 stories) when built and featured 25,000 square feet of marble inside. To the west is the Chemical Building, (1895, Henry Ives Cobb, and Mauran, Russell & Garder), with its "corrugated" Chicago-style façade, rising to 16 stories on the northeast corner of Olive and 8th Streets. Both buildings are "alive and well" today.

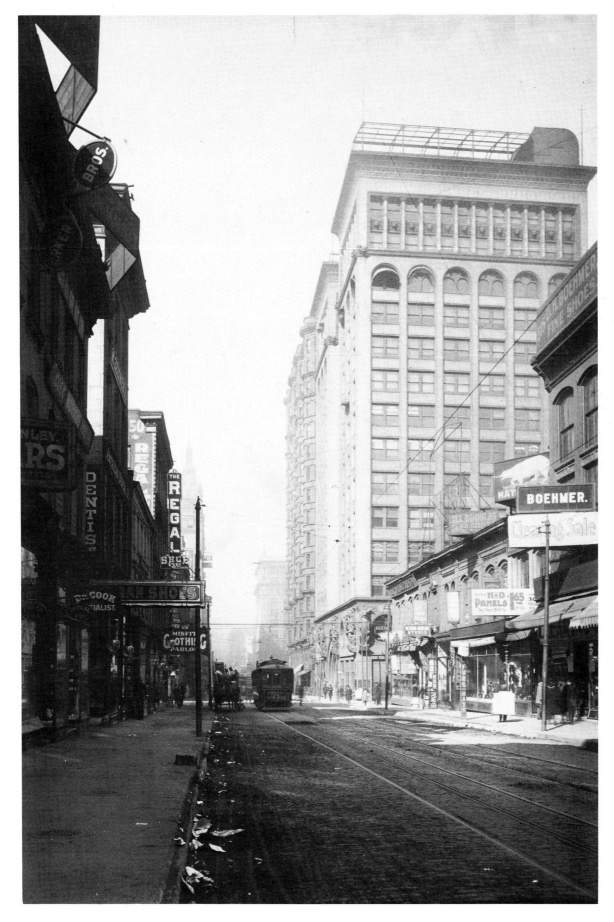

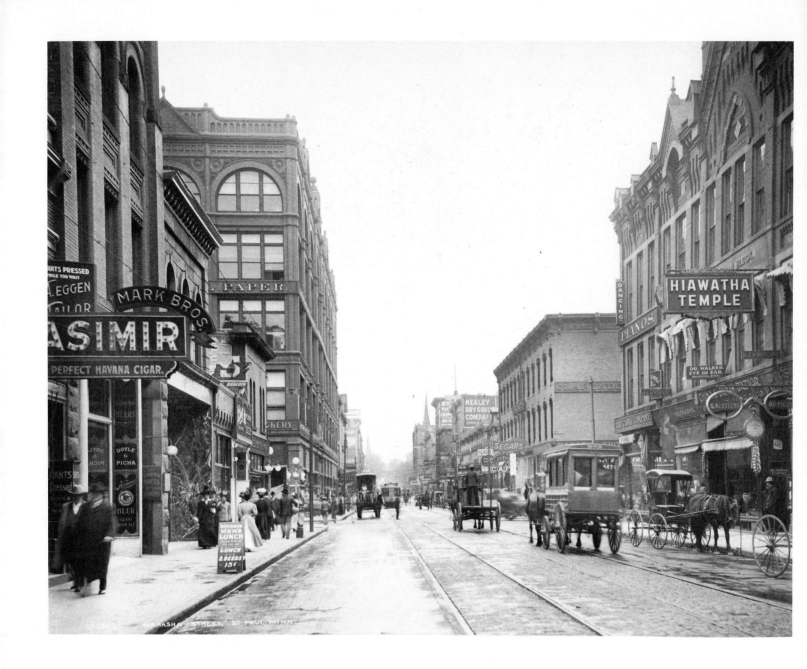

St. Paul, Minnesota, circa 1907 Nothing in this view is visible today. Many of these buildings were demolished in the wave of urban renewal that swept the country in the mid-twentieth century, others were subjected to exterior alterations. Looking up Wabasha Street (to the north) can be seen one such now-changed survivor, the five-story Schuneman & Evans Department Store (1892), at the junction of 6th Street and Wabasha (to the left of center).

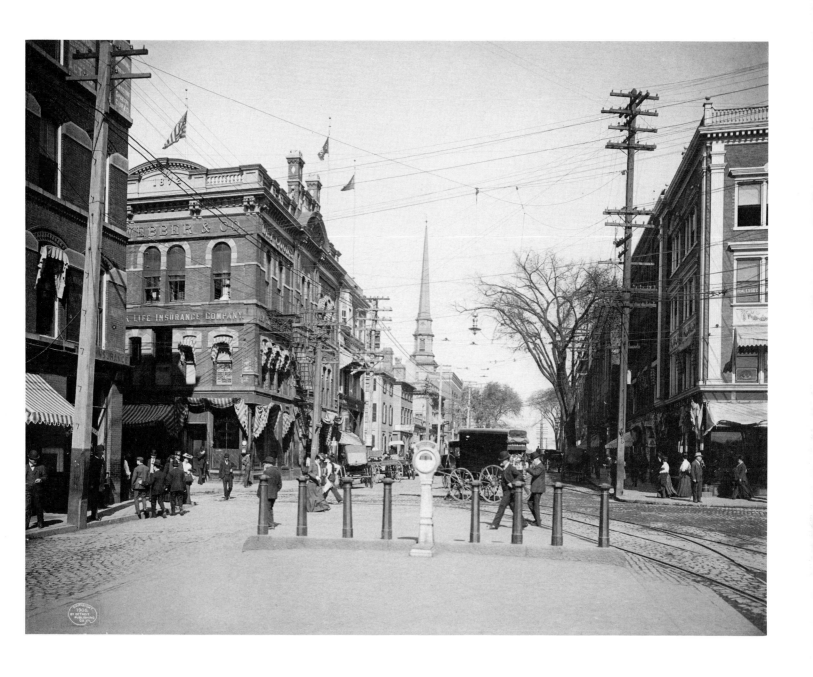

Salem, Massachusetts, circa 1906 This is the heart of downtown Salem: Town House Square. Here we look to the north on Washington Street from the intersection with Essex Street (in the foreground). The next cross street to the north is Bridge Street. The tall spire at center belongs to the Tabernacle Church. On the northwest corner of Washington and Essex is Wm. G. Webber & Co. (dry-goods establishment). City Hall (1838) is obscured by trees on the right side of Washington Street.

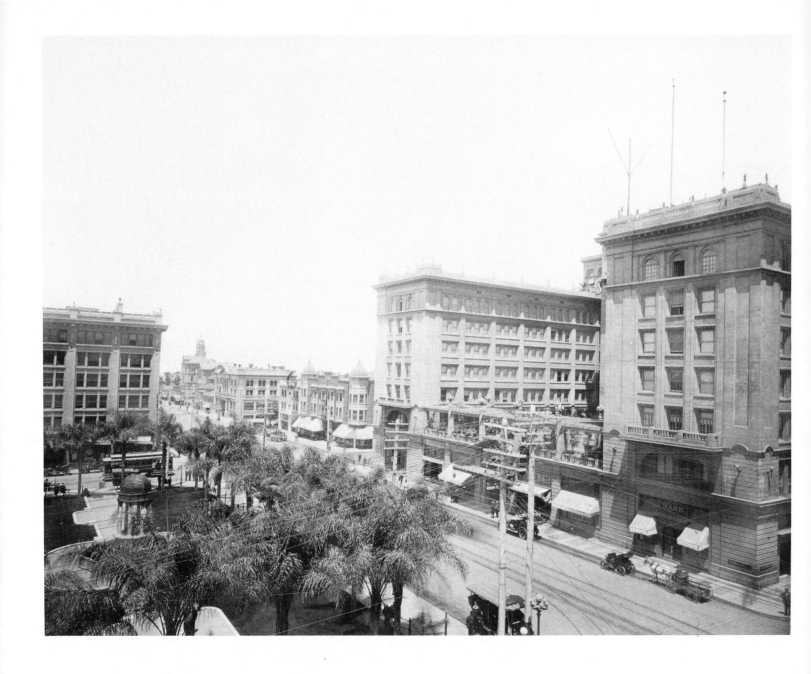

San Diego, California, circa 1911 (ABOVE) Broadway traverses this photograph from the lower right to the west (and San Diego Bay) in the upper left. On the lower left is Horton Plaza, whose eastern edge is on 4th Avenue. The building at right is the cement-gray U. S. Grant Hotel. At the west end of Broadway is the distinctive clock tower of the Court House. Of this relatively unified architectural group only the U. S. Grant Hotel and Horton Plaza remain.

San Francisco, California, circa 1900 (OPPOSITE) Here is a photograph of a part of downtown San Francisco as it was before the catastrophic 1906 earthquake. Here we have Market Street, the central axis of San Francisco's street plan, looking toward the east. The tall building on the right (at the southwest corner of Third and Market Streets) is the Call Building.

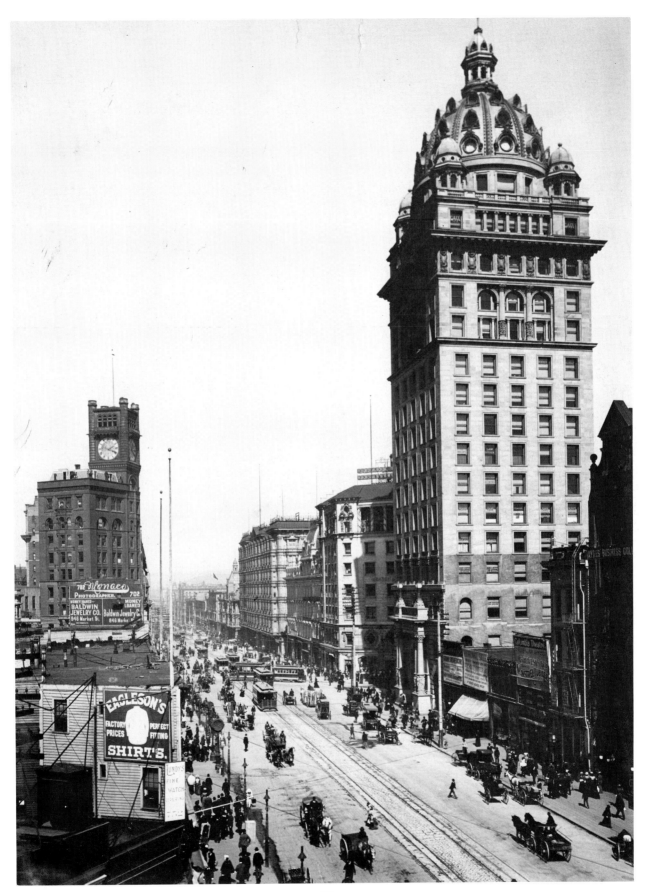

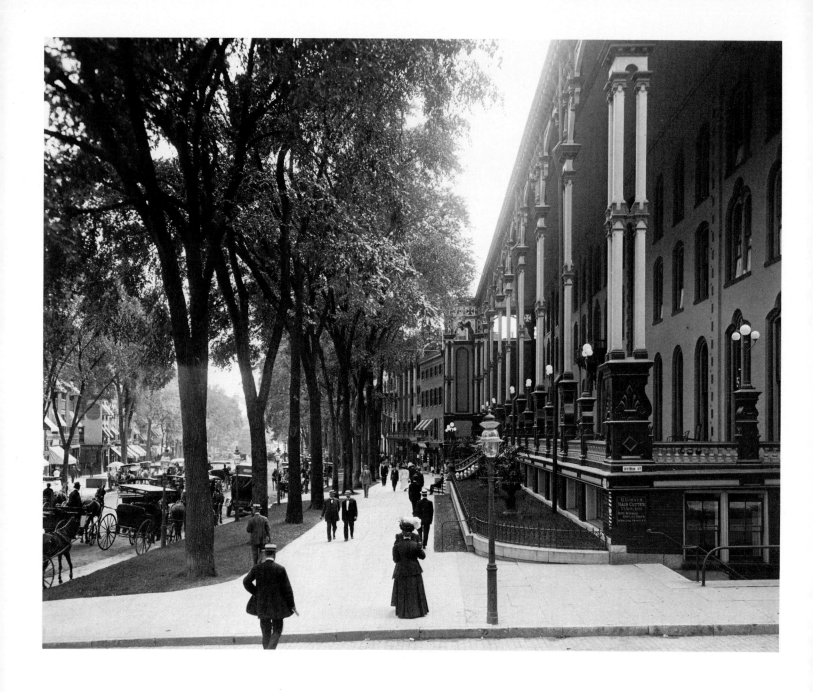

Saratoga Springs, New York, circa 1895 One of the great American summer resorts, Saratoga Springs was marked by the presence of voluminous Victorian hotels, built to accommodate visitors attracted by horse racing, spa waters and casino gambling. The United States Hotel (right) was inaugurated in 1874, following the fiery demise of its predecessor at the same location (1824–1865). With a price tag of $900,000, it had over 900 rooms, 2,500 doors and four million bricks (seen here is the 230-foot side facing Broadway). The photo was taken from Division Street and faces south in the direction of the Adelphi Hotel (center) and the American Hotel. The United States Hotel, featured in the film *Saratoga Trunk* (1945), was razed in 1946.

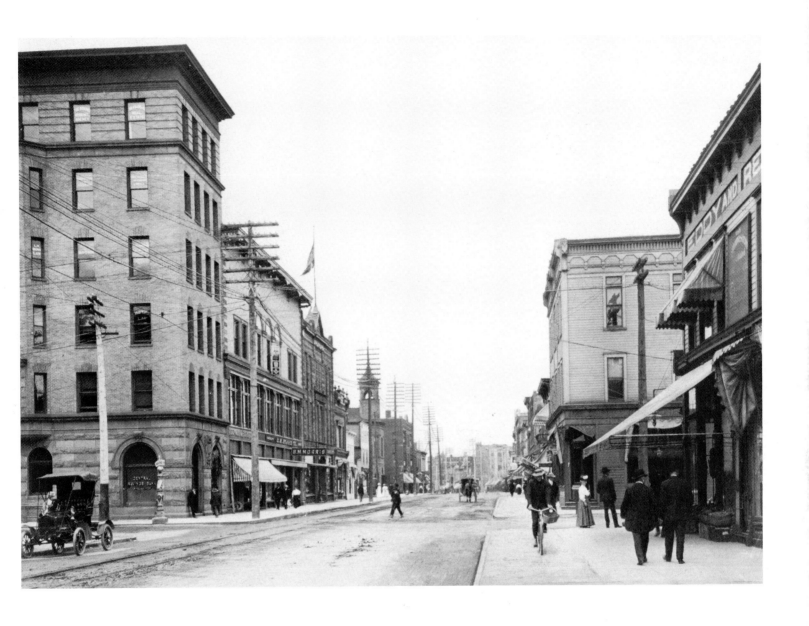

Sault Sainte Marie, Michigan, circa 1906 The seat of Chippewa County, in Michigan's Upper Peninsula, Sault Sainte Marie stands at the confluence of Lakes Superior and Huron. It benefits from the presence of the St. Mary's Falls Canal, which bypasses the 22-foot drop from lake to lake. In this photo we are looking north up Ashmun Street. The cross street (foreground) is Spruce Street.

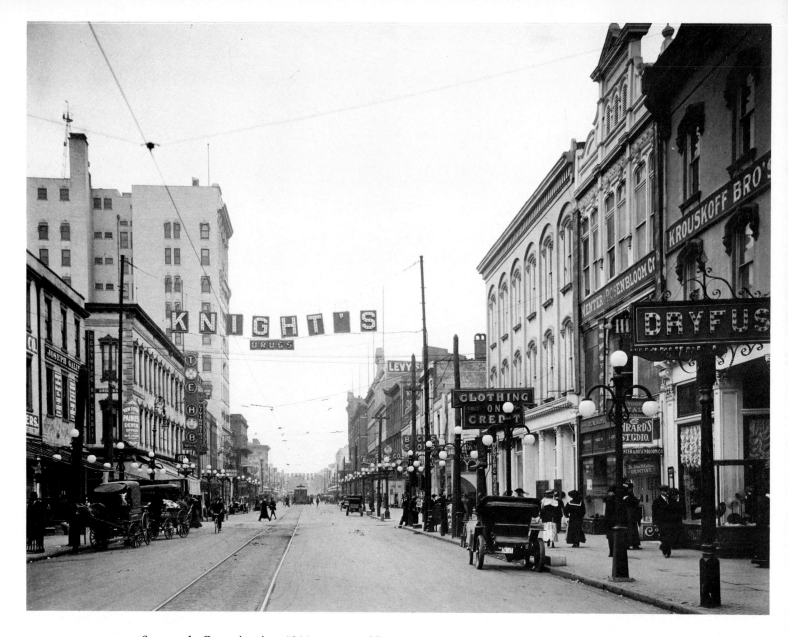

Savannah, Georgia, circa 1911 (ABOVE) This is the business district of downtown Savannah. The street is West Broughton Street, looking west. The camera has been placed on West Broughton between Barnard and Whitaker Streets. Some of the identifiable establishments in this view include: The Hub Clothing Co. (28 W. Broughton); Livingston's Pharmacy (26 W. Broughton); Krouskoff Bros., milliners (109 W. Broughton); and B. H. Levy Bros. & Co. (7–9 W. Broughton).

Seattle, Washington, circa 1903 (OPPOSITE) This Tlingit totem pole is in the heart of downtown Seattle, Pioneer Square. The pole was removed from Tongass, Alaska in 1899 by a group of socialites on a goodwill trip who, finding the village semideserted, sawed down this ancestor memorial as a memento. The pole was set up in Seattle that year in an official ceremony and, though those responsible for the theft were later fined, it remained as a Seattle landmark. The pole burned in 1938 and was replaced by Tlingit carvers. From this point we are looking south down First Avenue South. Much in evidence are the stone and iron structures built in accordance with a building code revamped following the 1889 fire. On the extreme left is the Olympic Building (destroyed 1973) fronting on Yesler Way (going off to the left). On the extreme right is the Yesler Building (on Yesler Way as it continues off the right edge), and, behind it, the Schwabacher Brothers Wholesale Grocers Building.

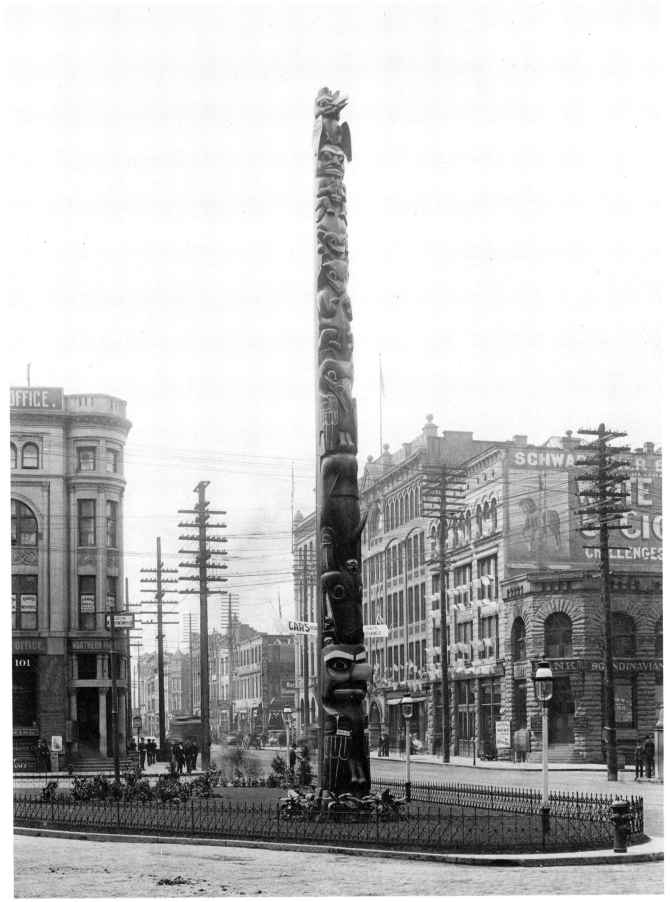

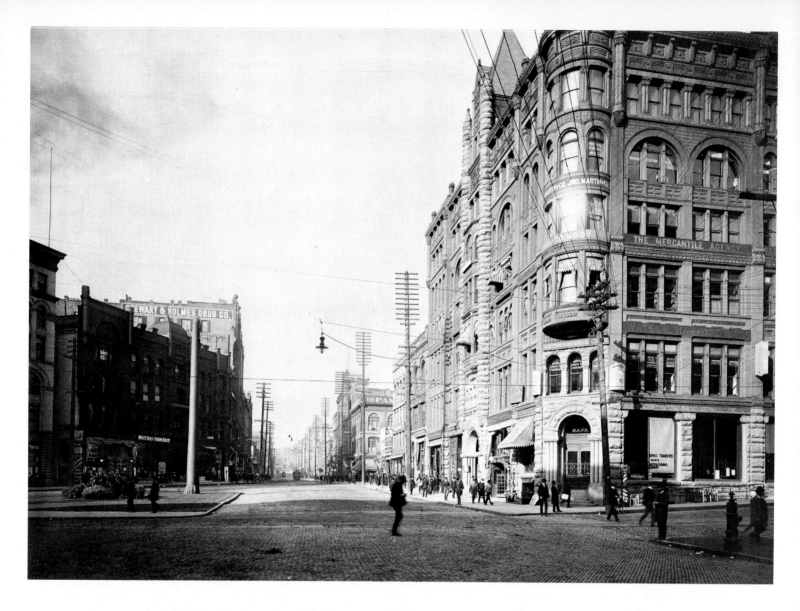

Seattle, Washington, circa 1900 (ABOVE) The building at the far right of this photograph was designated "the finest building west of Chicago" at an 1892 meeting of the American Institute of Architects. It is the Pioneer Building (1890), designed by Elmer H. Fisher, a Scottish architect trained in Massachusetts. Fisher designed over fifty Seattle buildings between 1889 and 1893, most notably in the Richardsonian Romanesque style, characterized by rough-hewn blocks of stone, Romanesque arches and accentual moldings. The main entrance is on 1st Avenue (the center street looking north into the distance), though the building also fronts on Yesler Way (foreground). Just north of the Pioneer Building is the three-story Howard Building. Toward the left side of the photo is Pioneer Square with the Seattle totem pole, the Mutual Life Building (extreme left), the Starr Building (right of Mutual Life) and the Kenneth Hotel (with the drug-company sign).

Springfield, Massachusetts, circa 1910 (OPPOSITE) Here is the financial center of Springfield. The street crossing from right to left in the foreground is Worthington Street as it passes Main Street, the latter stretching off toward the south along a vista of awnings. On the southeast corner of Worthington and Main is the Hotel Worthy (1895, renovated 1905), which is still standing. Adjacent (to the right) is the Phoenix Block (1895), which was used as an office building. South of the Phoenix is the eccentric, onion-domed Fuller Block (1887–1889), just north of Bridge Street, and still in existence. On the southwest corner of Worthington and Main is the Whitney Building (1890's).

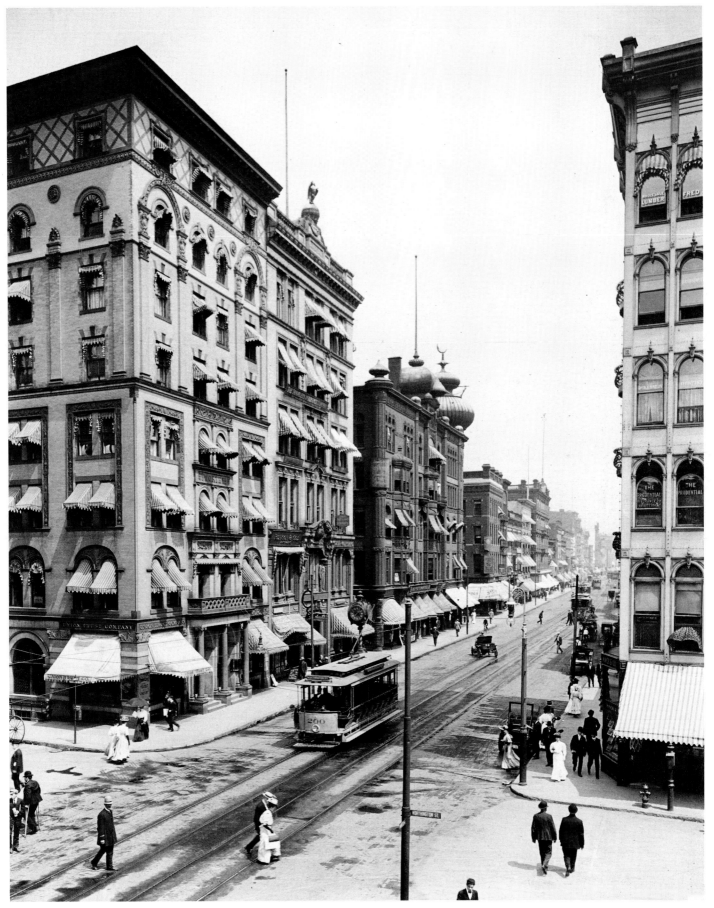

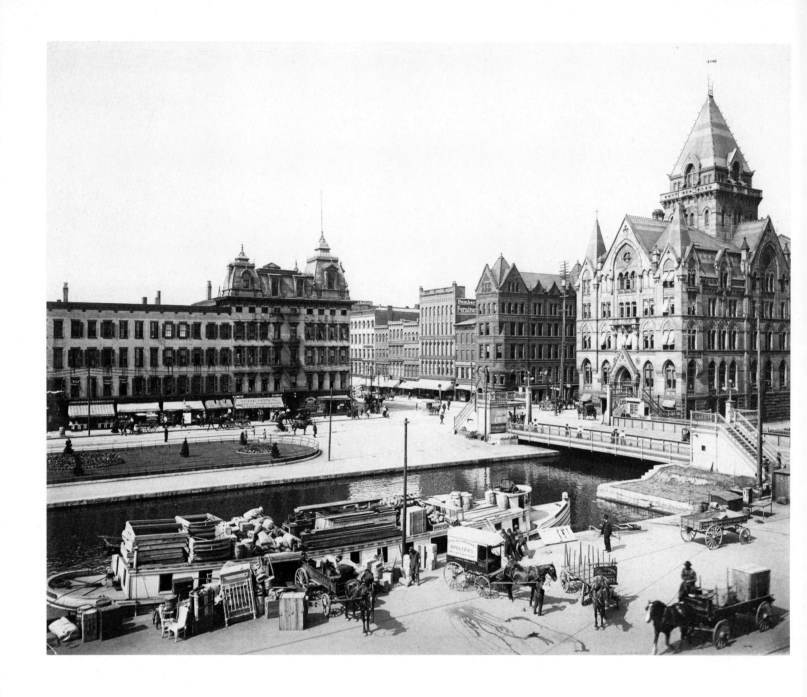

Syracuse, New York, circa 1901 This is the heart of Syracuse and its "Main Street." The open space across the barge canal is Clinton Square. The row of buildings extending from the right edge of the picture to just left of center is on North Salina Street (Salina being Syracuse's main thoroughfare), which runs from north (left) to south (right) in this view. In the foreground is Water Street. The large building (extreme right) is the Syracuse Savings Bank (1876, Joseph Lyman Silsbee), a notable example of High Victorian Gothic, steel-framed and still standing. The long building mansarded at one end is the Empire House (extreme left).

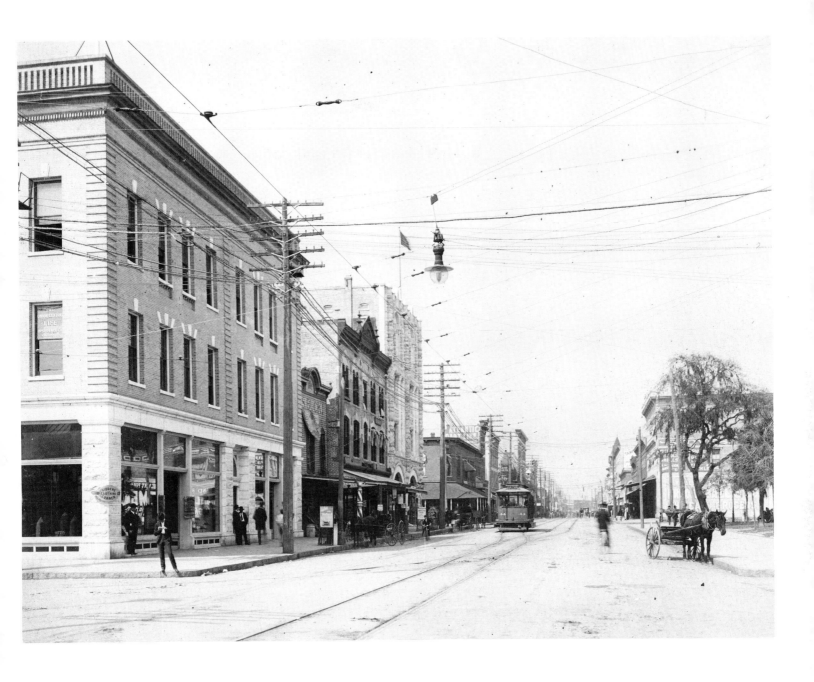

Tampa, Florida, circa 1900 Running (right to left) across the foreground is Lafayette Street (now known as Kennedy Boulevard), and we are looking north up Franklin Street. At the extreme right of the picture is Court House Square. The rough stone façade (center) with two Romanesque arches at street level belongs to the First National Bank.

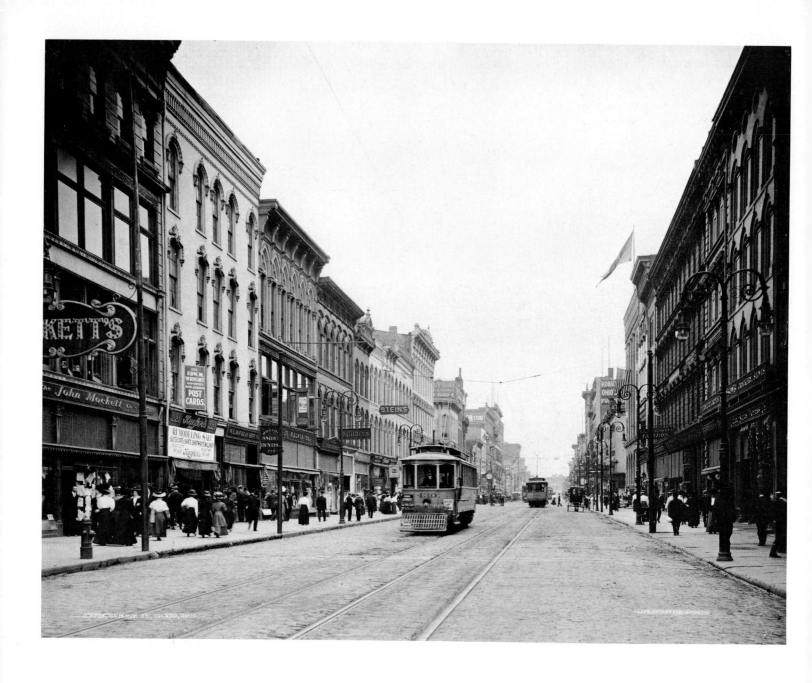

Toledo, Ohio, circa 1895 This is the commercial center of Toledo. We have Summit Street (the 200 block) looking to the northeast, where the next intersection is with Madison Avenue. Summit parallels the course of the Maumee River.

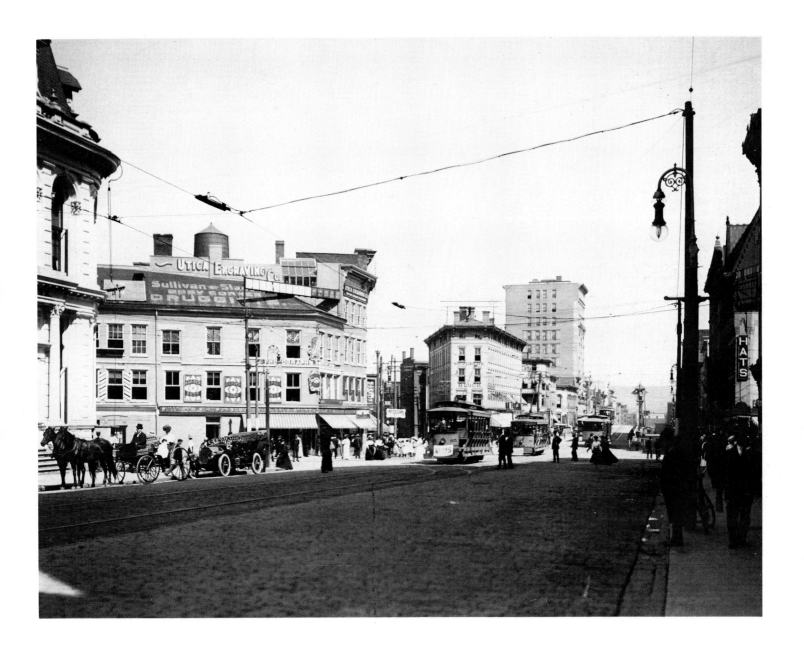

Utica, New York, circa 1910 This photograph depicts the hub of downtown Utica looking up Genesee Street to the north, the "Main Street" for businesses in Utica. From the vantage of the photographer the next streets to the north are Bleecker Street (on the right) and Lafayette Street (to the left). The meeting of these streets was (and is) called the "Busy Corner," an important trolley-line crossing at the time of the picture. At extreme left is the Savings Bank of Utica (1870, destroyed 1912) with its cast-iron façade. The building group to the left of the nearest trolley (No. 65) is still standing, as is the 1845 Devereux Block (right of center) and the tall structure to its right, originally the Utica City National Bank (1903) and now seniors' housing. The control tower of the bridge that took Genesee over the Erie Canal (both the bridge and canal were gone by 1922) is visible in the right-hand distance.

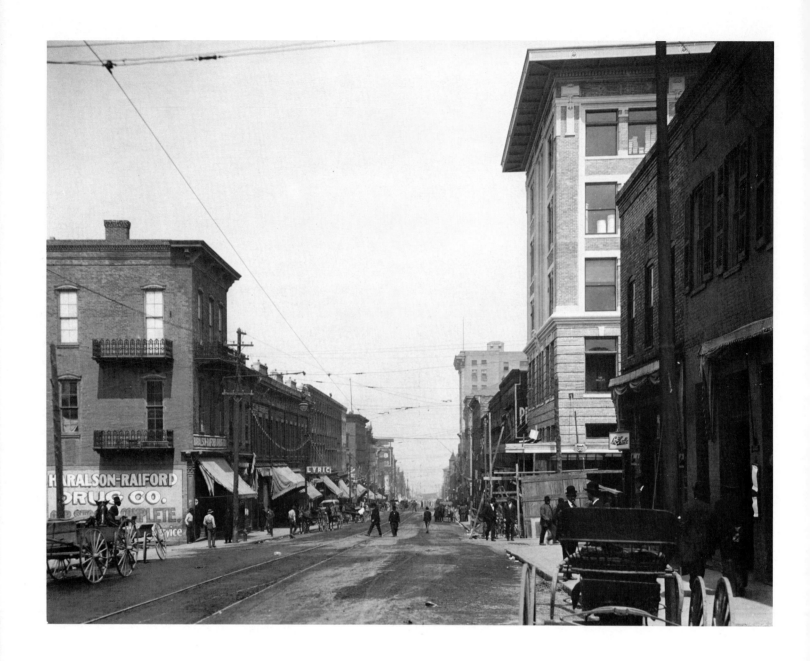

Vicksburg, Mississippi, circa 1900 Here is the mercantile zone of Vicksburg, Washington Street, looking toward the north. Crawford Street is the next intersection to the north, followed by Clay Street. The tall building on Crawford Street (second from the right) is the Merchants National Bank (building demolished). The other tall building further north, at Washington and Clay, is the First National Bank, which is still there. This whole scene has since been modernized, and is known as the Washington Street Mall, a pedestrian-oriented shopping area.

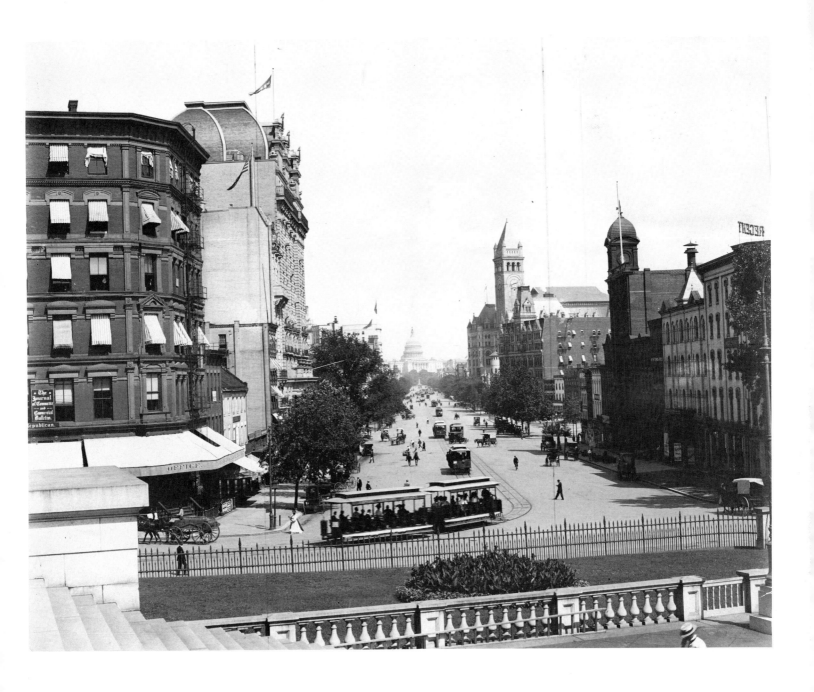

Washington, D.C., circa 1905 Pennsylvania Avenue is one of the most important axes of downtown Washington, connecting the Capitol Building (center distance) with the White House/Treasury area. Here we are looking southeast on Pennsylvania from the Treasury. The dark tower (on the right) belongs to the Grand Army of the Republic (G.A.R.) Building (no longer extant). The other tower (right of center) belongs to the Old Post Office (1891–1899, Willoughby J. Edbrooke). The large building (left of center) flying a banner from its roof is the Willard Hotel (1900–1904, Henry J. Hardenbergh). One of the prime foci of Washington political and social life, it replaced the Old Willard Hotel (1850) where Nathaniel Hawthorne, Abraham Lincoln and many others stayed. The Willard and the Old Post Office have both been restored in recent years.

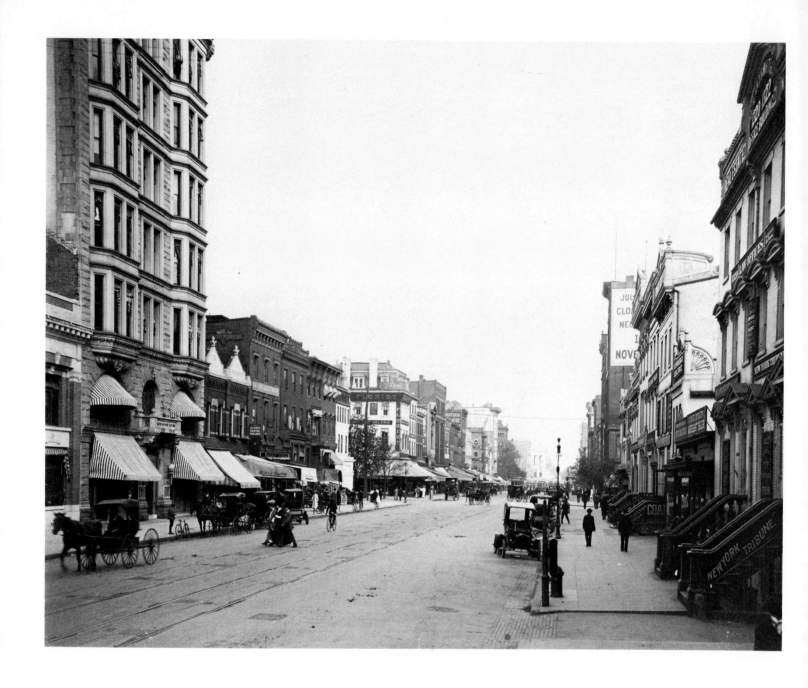

Washington, D.C., 1906 Here is Washington's mercantile and commercial center just after the turn of the century. The tall building (left) with striped awnings is the American (National) Bank Building. Offices of the *New York Tribune* can be seen at extreme right. Throughout most of the nineteenth century this stretch of F Street (seen here from between 13th and 14th Streets) was an elegant section of residential town houses, but by the time of this photo commerce had clearly taken priority.

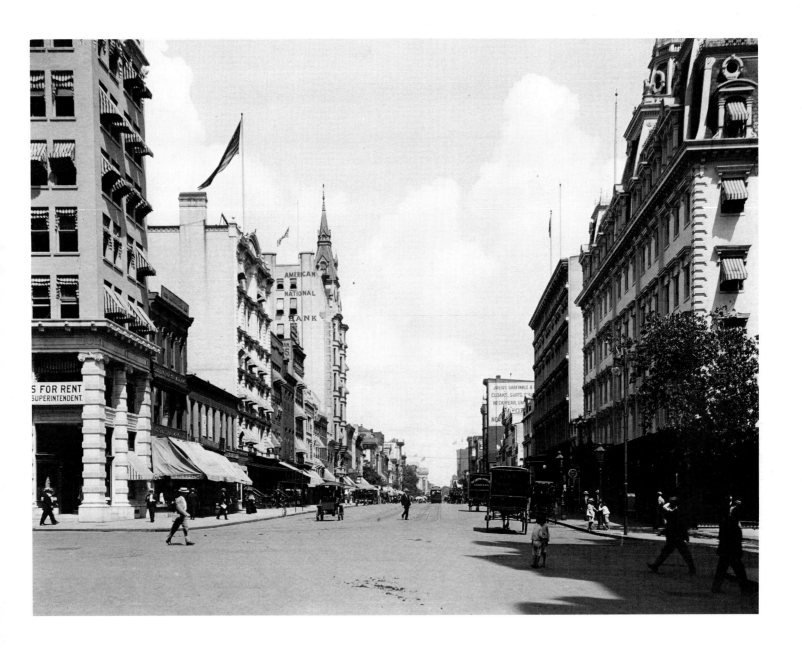

Washington, D.C., circa 1904 Around the time this picture was taken, F Street between 7th and 15th Streets was becoming a fashionable shopping zone, particularly between 10th and 14th. This photo looks east on F Street from 14th Street. At extreme right is the Ebbitt House (1872, razed 1926, replaced by the National Press Building), a favored haunt of journalists and home to President McKinley before moving into the White House. The spired structure (left of center) is the American (National) Bank Building, which no longer stands, although a good number of the buildings along the north side of this stretch of F Street do remain, including the one in the left foreground.

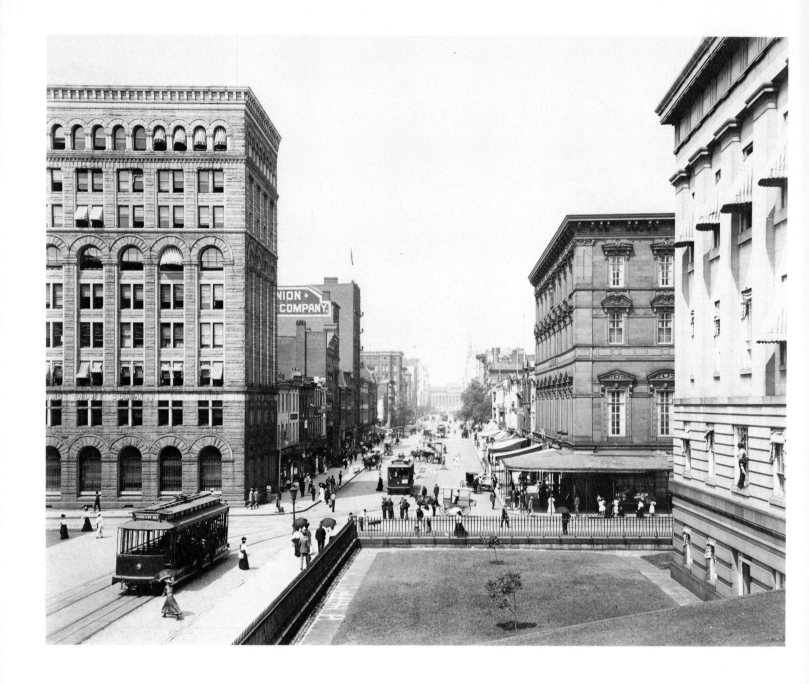

Washington, D.C., circa 1900 By the time of this photograph, this strip of F Street had become heavily mercantile in nature, a focus for shopping, banking and related activities. From the Old Patent Office (1836–1867, William P. Elliott *et al.,* right foreground)—which served as a hospital in the Civil War where Clara Barton and Walt Whitman tended to the wounded, and which now contains the National Portrait Gallery and the National Collection of Fine Arts—one looks west on F Street to the Treasury Building (1836–1869, Robert Mills *et al.,* center distance) on 15th Street. 9th Street is just west of the Patent Office. On the northwest corner of 9th and F is the Old Masonic Temple; on the southwest corner is the Washington Loan and Trust Company Building.

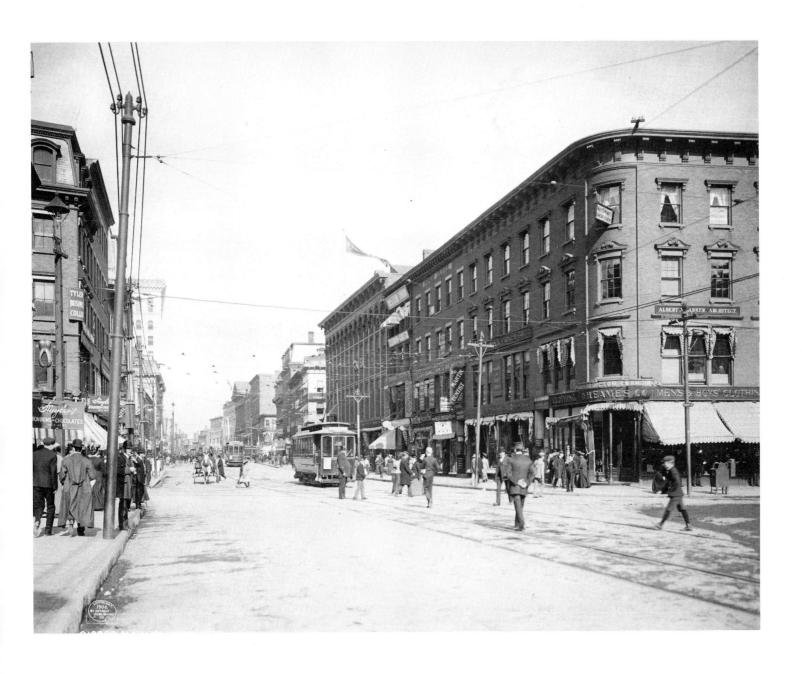

Worcester, Massachusetts, circa 1906 Here is the commercial center of Worcester, looking north up Main Street. The street crossing from right to left just north of the camera position is Front Street. At extreme right is the Harrington Corner Building, to the north of which is the Piper Block.